"Love has torn us apart." *

For James.

For all the kids who I grew up with in Santa Cruz — stay golden.

Live forever all things Manchester, Factory Records, Haçienda, post-punk, Madchester, baggy — thank you for providing the soundtrack to my life.

# JOY DEVOTION

## The Importance of
## Ian Curtis and Fan Culture

EDITED BY
JENNIFER OTTER BICKERDIKE

www.worldheadpress.com

# CONTENTS

# CONTENTS

VII

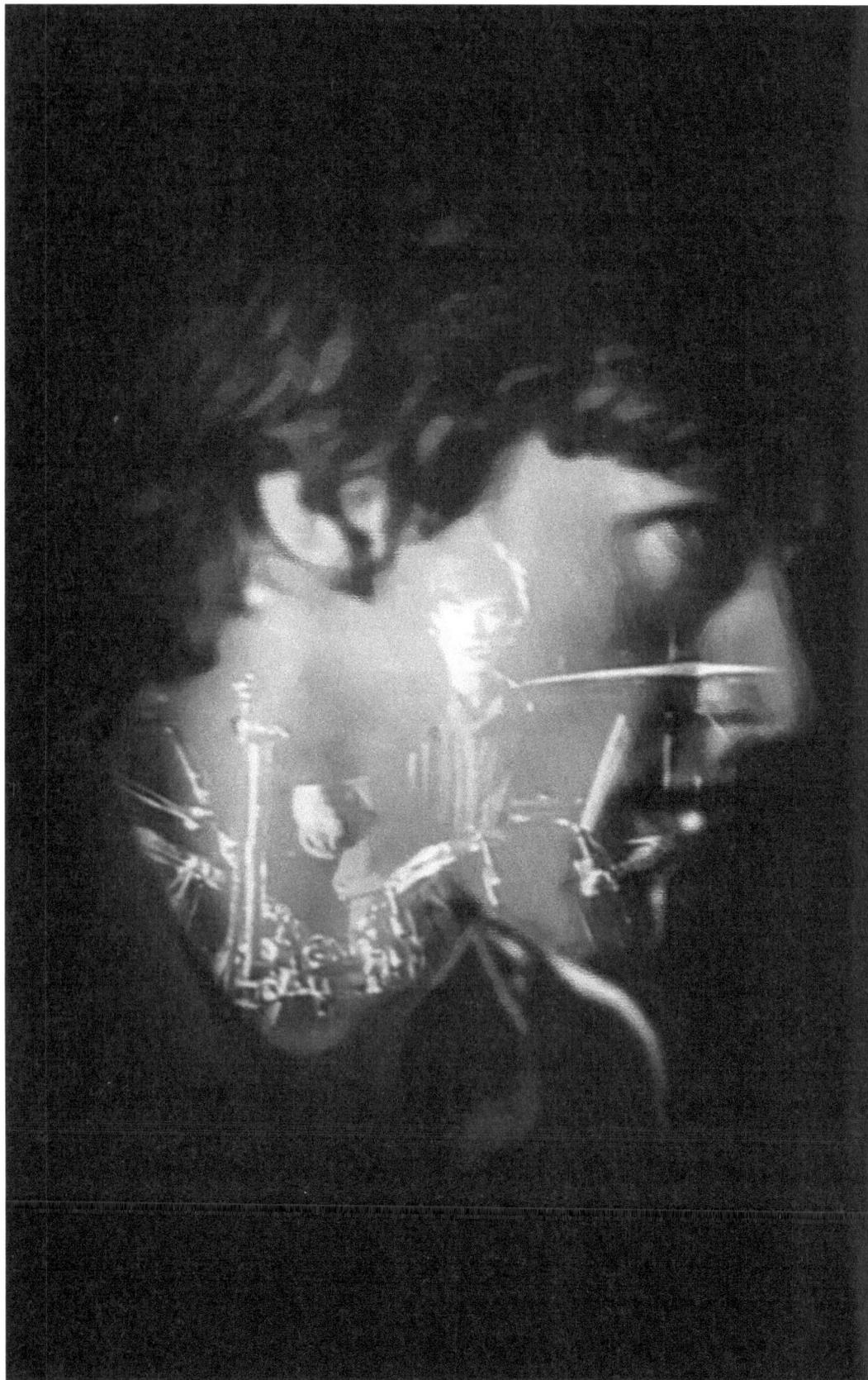

# THE ORDER OF THINGS

## Joy Division & New Order

### STEPHEN MORRIS

I n today's world awash with social media hype and criticism it seems odd to recall that over thirty years ago, when we were young and wild, we placed absolutely zero importance upon how Joy Division might be perceived by the world at large. That, I suppose we thought, if we considered the matter at all, was the job of the world at large and not really our problem. They'd only get it wrong anyway, whatever they thought. We would be nothing like that really, just be ourselves, be neutral, uncontrived, have no image, and if they didn't like it well fuck 'em. The music would speak for itself.

Which is fine as far as it goes. Most bands start out with a very similar manifesto. Thing is, the people who hear that music will add their own impressions of you and your music, and all your attempts at avoiding this will be conceived as the thing itself.

This was a time when marketing was something that mostly applied to fancy drinks or boxes of cornflakes, frivolous things. Music is much MUCH more serious than that! Cornflakes will never break your heart the way that music can. The best music does not have a sell-by date either. Some of our songs they say are "timeless" — I wouldn't know.

Jennifer's book is a seriously good, considered, and well written study on the curious interaction that takes place between the music and the fan. An interaction that can give meaning, security and identity in a world where these things are in increasingly short supply.

Stephen Morris,
*Drummer, Joy Division & New Order*

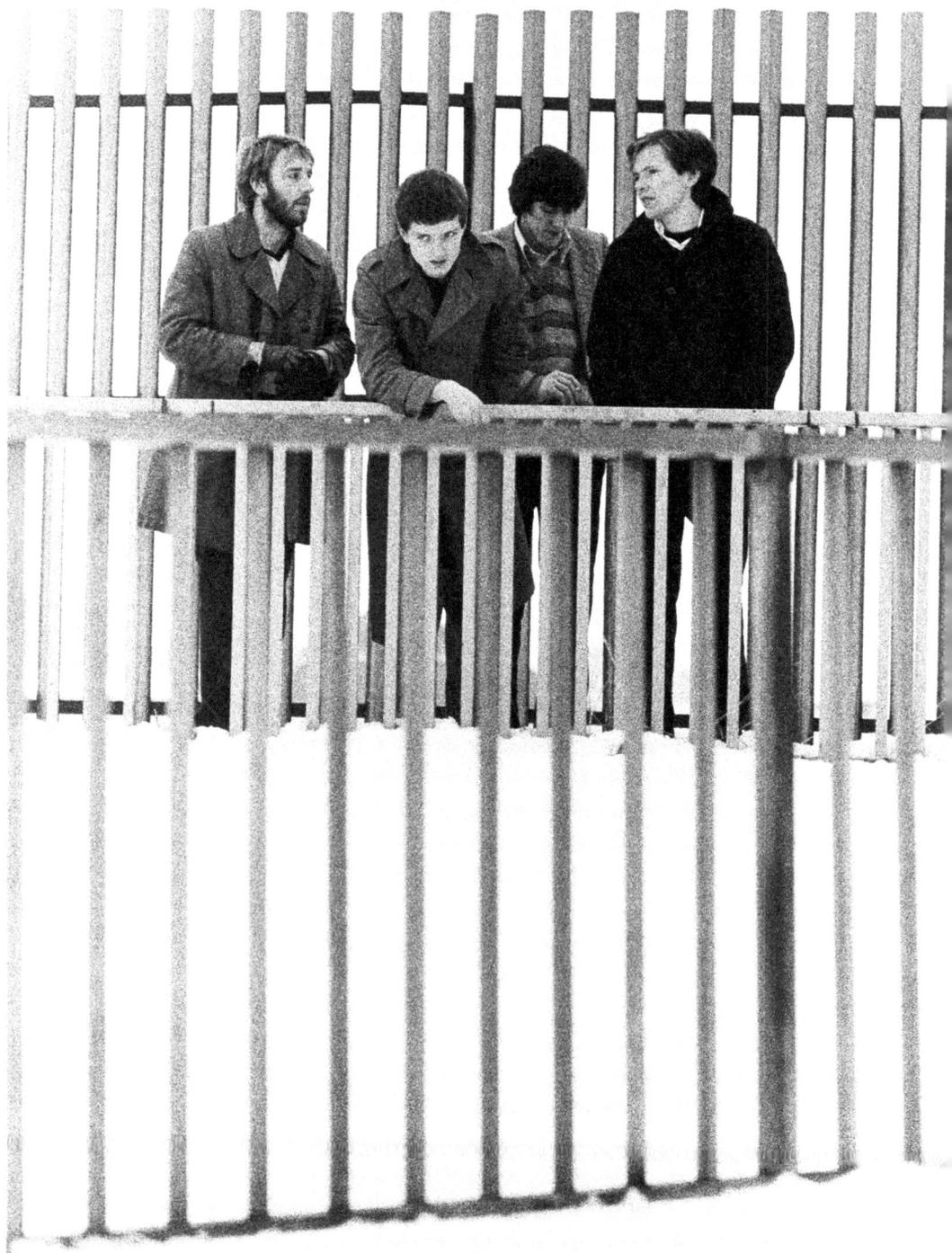

Joy Division in Hulme, Manchester, January 6, 1979. L-R: bassist Peter Hook, singer Ian Curtis, drummer Stephen Morris and guitarist Bernard Sumner. (Photo by Kevin Cummins/Getty Images)

# THE POWER OF IMAGE

## Kevin Cummins

**INTERVIEWED BY JENNIFER OTTER BICKERDIKE**

Kevin Cummins is the legendary photographer best known for his iconic shots of music luminaries, including Joy Division, New Order, Morrissey, the Smiths, the Happy Mondays, Oasis, David Bowie and the Stone Roses. His many accolades and accomplishments include a two ten-year stint as chief photographer for the *NME*, being a founding contributor to *The Face*, and having his pictures used extensively in films, including Grant Gee's *Joy Division* and John Dower's *Live Forever: The Rise and Fall of Brit Pop*. Cummins' work is often exhibited around the world and is highly influential in sustaining the images and ideas of the post-punk through Madchester music scenes in his native Manchester, as well as providing inspiration for generations of fans and artists alike.

The interview with Kevin Cummins that follows takes place on a Friday afternoon in April 2016, the location being the Boot and Flogger pub in Southwark, London. Also present is David Kerekes. Outside it's raining heavily.

The staff has graciously set aside a private room for us, but in the end we opt for the bustling bar area: after all, a pub is a pub, and it makes for informal chat, touching all bases Manchester and the Manchester heart. The conversation addresses the mythology surrounding the city's recent past, through one who was very much part of its construction. "I often get asked," says Cummins, early in our meeting, "'What is the most important picture you have ever taken?' I think the most important picture is one I did not take." This he says in relation to the Sex Pistols gig at the Lesser Free Trade Hall in June 1976, a cultural cornerstone, but also an event that increases in stature and crowd number as time goes by — symptomatic of the meretricious nature of fan culture. "If I had taken a camera, instead of just going to see it," says Cummins, "and turned my camera on the audience, it would have destroyed

the whole mythology of Manchester: we would know who every one of those forty-eight people in the audience was."

Looking back at the pictures he took of Joy Division, those on Epping Walk Bridge in the snow and Ian Curtis looking into the camera smoking — described by one critic as the most important pictures of the twentieth century — Cummins is self-effacing but also rightly conscious of the role he plays. "I was twenty-five when I took those pictures," he says. "I was taking them for the following week's *NME*. I wasn't taking them thinking in thirty-five years' time I will still be talking about them, and I will be receiving an honorary doctorate from Manchester Metropolitan University. But you know, it's amazing that these pictures have helped define my city. So I am really proud of that, I am massively proud of that."

### Do you remember the first time you saw Joy Division?

**Kevin Cummins:** I saw Joy Division's first gig, when they were Warsaw. Richard Boon, who was the manager of the Buzzcocks, offered a support slot to open for them at the Electric Circus in May 1977. They were not very good. And they were not very good for a while. They were outsiders. They didn't live in Hulme, and they didn't hang around with the same group of people I did. They couldn't really play. They had a few songs. And they had that faux anger that everyone who was in a punk band ought to have. They had PVC trousers and moustaches! They were just another band. I took some pictures of them as I would anybody that was playing, just so I had a record of it. They were just

normal lads. They were kids the same as us: into music — Ian liked football — everyone talks about girls and drinking. It was no more cerebral than that.

Prior to that, we had heard little bits about them, as we all used to go to gigs together. Even though people would not 'know' each other — it's like when you come to a bar, you look around — you see the same people. You might never know their names, but you have 'known' them for quite a long time. It was similar in Manchester. Manchester is quite a small city, really. There was a nucleus of about fifty people who used to go to gigs all the time, you would see them. Occasionally you would say, 'Have you heard of the Sex Pistols? Are you going to go and see them?' Pistols at the Lesser Free Trade Hall is always the one that people cite as the catalyst for everything that started in Manchester; but actually, I think it was when [David] Bowie played The Apollo with Iggy Pop in March 1977, when they toured [Pop's] *The Idiot*. People think of it as being the Pistols gig which was the pivotal moment — punk changed everything, in a way — although it did not change anything. At the time, it was vitally important. Then it became what it had tried to destroy. So I think it was really when Bowie played the Apollo with Iggy — that is what galvanised people. In London, punk came out of pub rock. The lineage in London was Dr. Feelgood and Eddie and the Hot Rods — then the Sex Pistols and the Clash. In Manchester, punk came out of glam rock. Everybody was into Bowie, Roxy [Music] and Marc Bolan and stuff like that. They were the people who then went on to form punk bands. That is how it happened.

*Is Ian Curtis a one-off, or is he just one of a canon of 'tragic' artists?*

Ian is like Richey Edwards [lyricist and guitarist of the Manic Street Preachers. Edwards disappeared on February 1, 1995, and was presumed dead in November 2008]. He has that tragic thing where he wrote lyrics which appeared to be intensely personal. He is part of a canon of tragic artists. It's terrible to say this, but we love our heroes to die young. I think there is a certain romanticising about people dying young — but only for outsiders. It's not romantic for anyone who is part of that family or who loved that person. Same with James Dean, same with Kurt Cobain, same with Amy Winehouse. It's a fucking tragedy. It's a tragedy that somebody from outside should have spotted. It's very difficult. I wouldn't say with Ian we knew there was going to be a tragic end to his life — we didn't think like that. I think possibly you did with Richey. We were a bit older and we had seen it a few times by then. With Ian, we didn't know that. We were all early twenties, and lads didn't really talk to each other about emotional stuff. You didn't really know that Ian's words were emotional. You have to remember — at the time, they were just seen as a punk band, a post-punk band. It was only with hindsight that people realised what was going on there.

The interesting thing about the Manics is that they continued as a band without Richey, and did not change their name. For a long time with the Manics, they would line up on stage exactly as they did when Richey was there. They would just leave a space in case he would come back. With Joy Division, once Ian died, they had to become a different band. None of them really wanted to sing. Bernard [Sumner] was sort of forced into doing it. Even though they toyed with the idea, Rob [Gretton, Joy Division's manager] did not want to bring an outsider in to sing. They were quite a close knit group of people.

*The subject turns to Joy Division and class background; whether 'scenes' and underground youth movements could exist without the working class to fire them. Cummins thinks not.*

We were all from working class backgrounds. I don't think we fully understood the class thing anyway back then. I think the reason music was so interesting then is that it came out of the working class, and people were able to live cheaply. You did not need a six figure salary to indulge yourself in playing guitar. You could get a government grant for wanting to be in a band, you could get your rent paid for, there were loads of places to squat, there were loads of places to live cheaply. There were a lot of developing cities. Once that stopped, it was really difficult. Kids did not have time to make music. They had to work.

*And how did being a young photographer fit into all of this?*

At the time, people could not afford to shoot on film unless they were commissioned. There were not rich kids around who liked that kind of music, who just went and shot loads of film just for the hell of it. Photography was not as accessible then as it is now. Digital has not only made it very accessible, it has made it very democratic. It

5

has possibly made it an art form that is no longer appreciated. Everyone thinks they are a great photographer.

With the pictures of Joy Division, I did not set out to take a picture that would be remembered for all time. Whereas when I took the pictures of The Stone Roses covered in paint, that was a deliberate attempt to take a photograph that nobody could follow. That was a picture that would capture the band and would become a defining image of that band. If I was a photographer commissioned to shoot them the week after somebody had done that shot, I would think there is no point. With the Joy Division pictures, the picture in the snow [on Epping Walk Bridge in Manchester] was such an un-rock'n'roll image that it became by default a picture that defined the band. I said to Bernard, 'The thing about that picture — it was bleak, and it had lots of space in it, and you could look at that photograph and know what that band sounded like.' I said to him, 'It defined your sound in a picture — that is not an easy thing to do. That picture, it has defined your music, it has defined the way you look.' It's the same with Ian looking straight into the camera. He's not looking at the camera — he is looking beyond it at me. What people don't understand about portrait shots is that when you take a picture, you almost have to make that person relate to you. I like those shots of him smoking — I like them all since I have lived with them for so long. I really like the ones of him in the rehearsal room, against the black walls, with him looking straight out. They were always my favourite shots. But the one of him smoking has become the shot that has defined him. Sometimes you have to make

the subject fall in love with you for ten minutes, or ten seconds, or whatever it is. You want them to look straight into your eyes, not just stop where the lens stops. They have got to look beyond the lens.

I think bands these days are too accessible. There is no underground anymore because of digital. Bands are forced to playing gigs too early. They can play a gig to six people — five of them are filming it, putting it on YouTube, and the other one is tweeting, saying the band are shit. When they come off stage, they have been slagged off by people who have seen the video on YouTube, or read the tweets.

What bands have to realise is that I don't want to see what they had for breakfast. I don't want to see pictures of them getting ready backstage, and I don't want to see pictures of them lighting their own farts after the gig. My job, I think, over the years has been to help build the mythology of rock'n'roll. Bands destroy it by being too easily available on social media sites. The great thing about Joy Division and what Rob Gretton understood is that they did not really have much of interest to say, especially to the rock press. Rob kept them away from it for quite a long time. That just made people more curious really.

People who were sixteen, seventeen, would sit in their bedrooms, doing their A levels, and listen to Joy Division and scare themselves to death. That is what discovering a band is all about. I said to Hooky when he wrote his book [2013's *Unknown Pleasures: Inside Joy Division*], 'I spent thirty years protecting the mythology of Joy Division, and you have written about Ian pissing into an ashtray.' Nobody wants to know that. People want to think he sat in the back of a bus reading

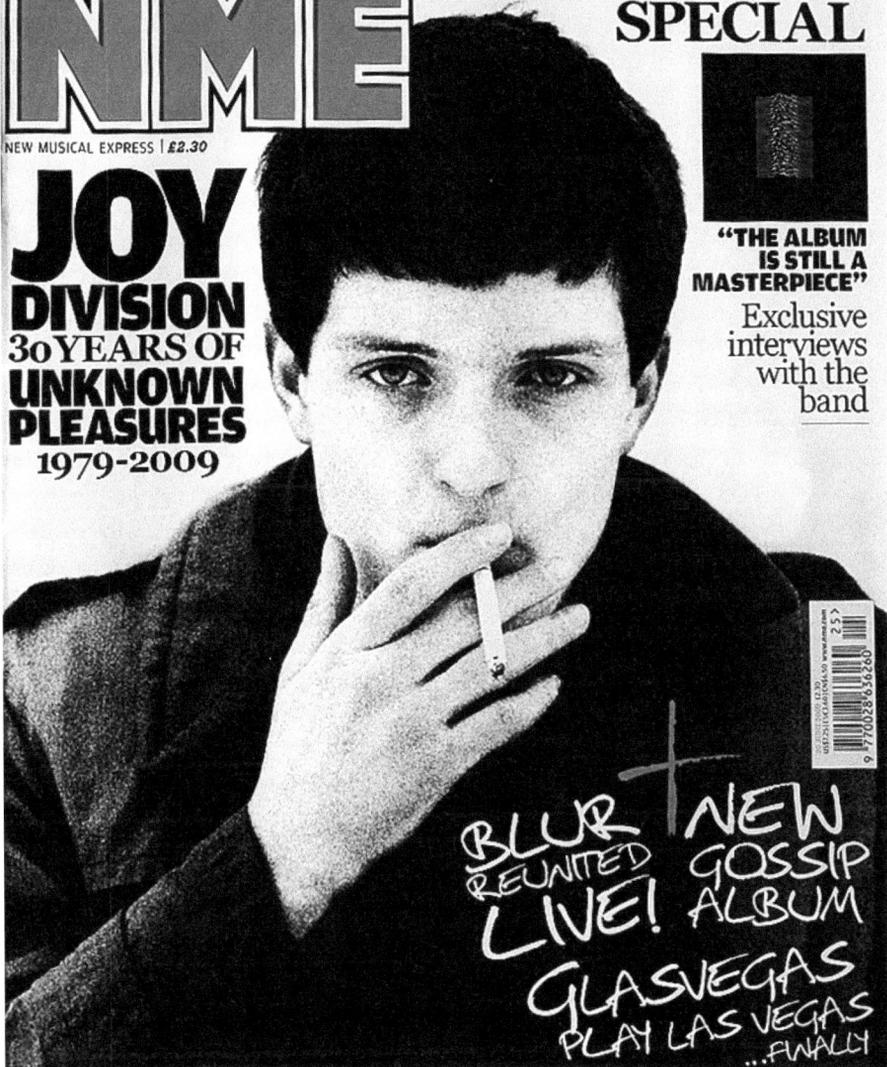

Dostoyevsky. They don't want to think that he pisses in ashtrays. I also said to him, 'It's probably not even true, because you can't remember much of it.' Whereas I can remember it because I was documenting it — that was my job.

*Joy Division and Ian Curtis have seeped into wider public consciousness recently through movie adaptations. It raises a question on what it must be like to see one's own life fictionalised and events in that life revered, often to the point of a eulogy. Would Joy Division be as iconic without Cummins' photographs?*

No. They [members of Joy Division] remember that time by looking at those

pictures, and bizarrely the film *Control* was based on my pictures. They even recreated the picture of Ian looking straight down the camera barrel for a fake cover of the *NME* with [actor] Sam Riley. Natalie Curtis [Ian's daughter] told me that when she went to the [film's production] office, they had all of my pictures pinned up on the style board. *Control* is just a fictional account. It's just an addition to many fictional accounts about Manchester.

I think what I was very conscious of when I was shooting for the *NME* was building a legacy. I think it's really important to do that, and not to go off chasing cash all the time. I turned a lot of work down, and sometimes they [*NME*] thought I was being really awkward because I would not go and shoot a certain band. But I did not think it fit into the portfolio I wanted to create. I wanted to create something that would have longevity. I didn't just want to go and photograph Aphex Twin one day, the Bluetones another day and Cud another day. I didn't want to do that. I wanted to work with bands and help to create their image without them realising that was what was happening in a way. I think each time you photograph somebody, you can take them up a step further. They are not really aware of it until they look back on the pictures. Joy Division had absolutely no interest in the visual side of it. They wore their office clothes, which looked like an extension of their school clothes. That was not a deliberate look. That was what people wore because they did not have much money. If they had had more money, they would have probably have dressed differently — like Ian when he got married, he bought a suit from Jonathan

Silver, a shop which was one of the first decent shops in Manchester to buy clothes — he would have bought himself something like that I guess. I think the fact that I can sit around and talk about pictures that I took at the start of my career with the Joy Division stuff, or even now the Bowie pics I took when I was at art school, are things that show I was right to be focused and single-minded about what I did.

I was doing a talk at Cornerhouse in Manchester about media manipulation with Tony Wilson, Bill Drummond and Paul Morley. Tony was talking about how I photographed Joy Division. I wouldn't want pictures of them smiling, because we wanted them to look like serious young men. That was the look and that is what we did. Tony was talking about the power of words, I was talking about the power of image. I said, 'Here are five of my *NME* covers. Tell me who wrote the pieces that went with them.' Nobody knew. I said to Paul Morley, 'You wrote two of them.' Afterwards, this girl came up to me and said, 'Have you got any pictures of my dad smiling?' And it was Natalie. I hadn't met her since she was a baby. We had a very weird night talking about it all. I was shooting a book on Man[chester] City [football team] — I had just started doing it. I think she was on a voyage of discovery because she was about to become older than her dad, which is a very very weird thing. She wanted to meet her father's friends, people that had been positive in his life. I got to know her a bit. She was in a photography course at the time. I took her to assist me on the Man City thing, just to get to know her a bit better. One day she turned up with a sky blue and white scarf,

and she said, 'My dad was a City fan, and I am now.' This was such a lovely moment. That's a very very strong memory, a very positive memory for me. The fact that I got to know Ian's daughter, and almost get to be a surrogate dad for a while. And she said to me, 'I only knew my dad through your photographs.' And I showed her a couple of pictures of him smiling that I have never published. She said, 'I think I prefer him more surly.'

I recently went back to Macclesfield and visited Ian's grave. It was a similar feeling as going to Père Lachaise and seeing how people desecrate things because they think they are important to them — and they do not give a fuck about the family. There is so much shit just thrown around Ian's stone — I think people at the crematorium should just put it in a bin bag every day and chuck it away. I am sure some people are very well meaning; but I don't want to go and see a memorial stone or a headstone, or a beautiful piece of architecture on a sarcophagus or anything where people said, 'You know what, the person in there is not as important as me.' It looks like the contents of someone's rubbish bag has been emptied over Ian's stone — and it's awful. That is not a memorial. That is just people making it about themselves. Fucking dreadful.

### What question do people ask the most?

The question I get asked the most is what was Ian like. Did I know he was going to kill himself? The answer is, nobody knew that. If we had known, don't you think we would have fucking done something about it? What Ian was like — he was a normal young lad who had gotten married too young — like working class lads did to get out of their environment. He had no real experience of life, he had never met anyone like himself. When you are in a band, whether you're interesting or not, you are of interest to lots of different people because they tag on to that. Girls tag onto it. Sometimes just because they like hanging out with bands, sometimes because it's sexual; lads are the same. When Ian first started going to Northern Europe, he started to meet like-minded people. No disrespect to Macclesfield, but you are going to meet someone a bit more fucking interesting in Brussels, or in Amsterdam or Paris. And you are also going to find people who are into your lyrics. When English is your second language, you are analysing those lyrics a lot more. He would meet people who wanted to introduce him to people who were incredibly well read, even at that age. And Ian thought, you know what, these are my people, this is the kind of thing that I am into. Ian would meet people who wanted to talk to him about his lyrics, and would understand him perhaps a bit more than people at home did. Like Stephen [Morris] has said, if we would have known what was going on with him, you like to think we would have said let's knock the band on the head for a couple months — but we wouldn't have. We would have said pull yourself together, you silly twat. Because lads would do that.

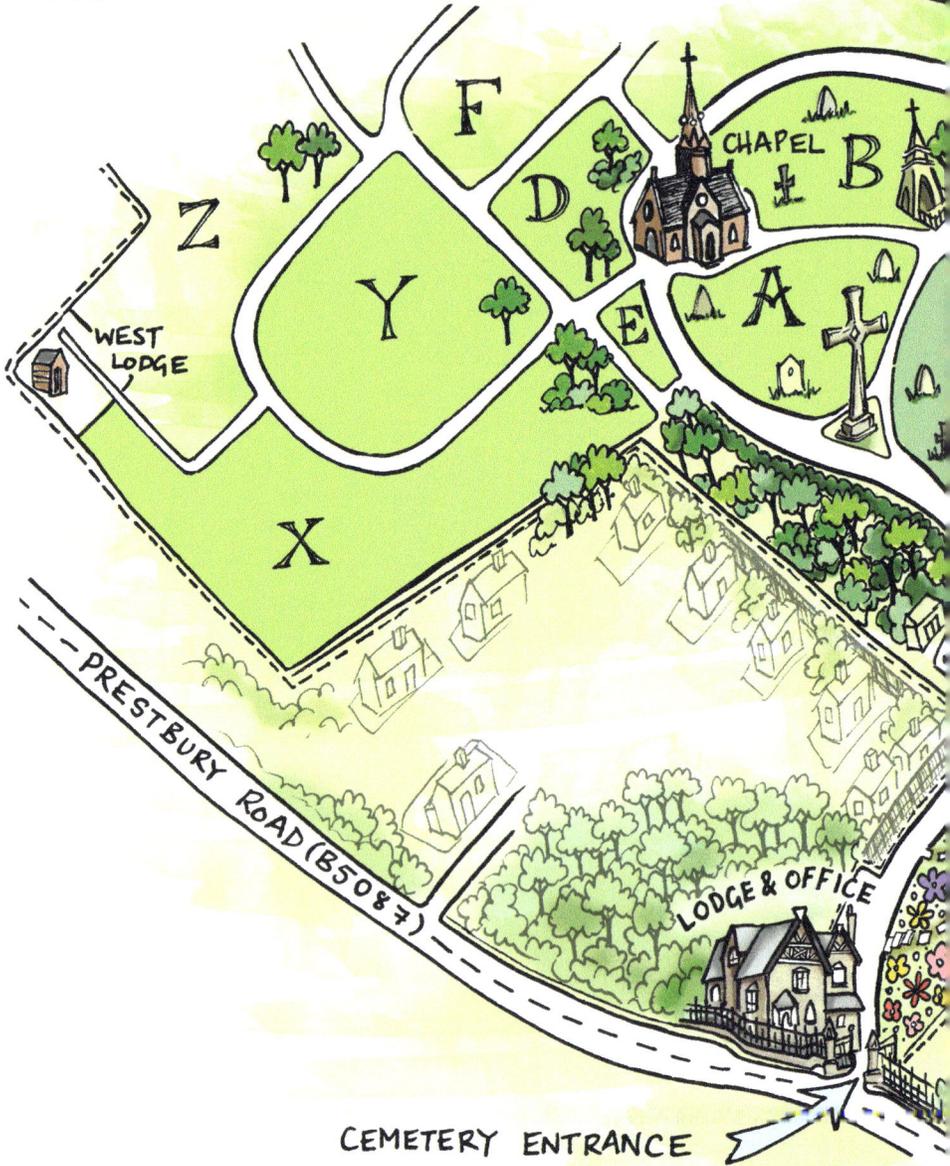

MACCLESFIELD CREMATORIUM

Z

F

D

CHAPEL

B

WEST LODGE

Y

E

A

X

PRESTBURY ROAD (B5087)

LODGE & OFFICE

CEMETERY ENTRANCE

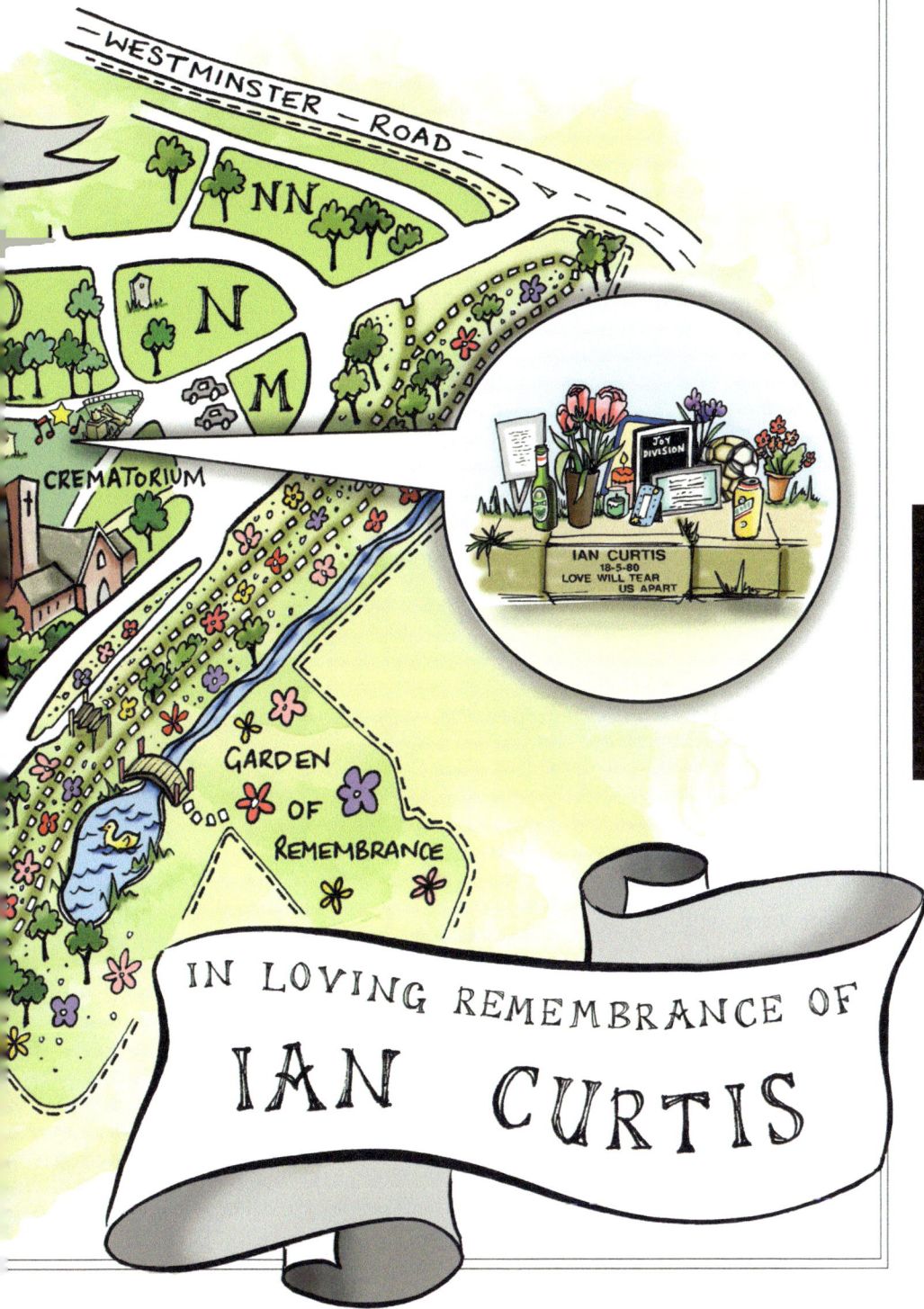

WESTMINSTER ROAD

NN

N

M

CREMATORIUM

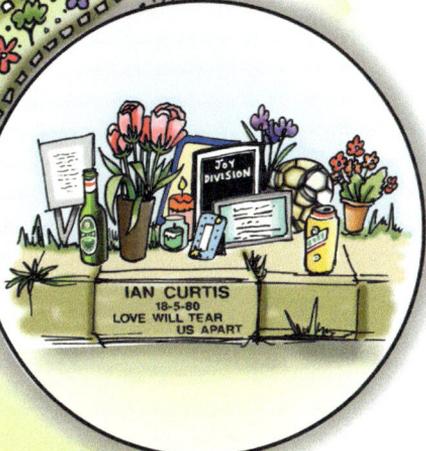

IAN CURTIS
18-5-80
LOVE WILL TEAR
US APART

GARDEN
OF
REMEMBRANCE

IN LOVING REMEMBRANCE OF
IAN CURTIS

# INTRODUCTION

## My only friend, Joy Division

### JENNIFER OTTER BICKERDIKE

Joy Division changed my life. They have been my friends and confidantes when feeling completely isolated, my 'therapist' when confronting the death of a loved one, and an inspiration for leaving behind everything I loved and knew to take a chance on a completely different life path. I can say with hand on heart, I owe them so very much; without them, I would most likely be in a gutter somewhere in downtown San Francisco, rocking gently side to side, sipping a bottle of paint thinner. They have pulled me through some of the toughest times, and been there to push me beyond what I thought were possible. The four boys from the North of England, one who I will never meet as he took his own life in 1980, have had more of an influence on the direction of my life than any teacher, class, or authority figure. It probably sounds weird to say a band can impact on you so much; but maybe it is not all about the band, or the songs, or the lyrics, or the subcultures that used to pop up around groups like Joy Division. Maybe it's because I grew up in the seventies and eighties, a moment when music, identity, ethos, values were important and integral in forming your personality. We did not have message boards where you could post anonymously to your heart's content in an intangible cyberspace about your personal woes and fears. No, our place of release and worship was the stereo, the Walkman, the cassette. Here, between the headphones, we found our communion, a place where we were not alone. It is here that Joy Division saved me, not once, not twice, but three times.

## THE FIRST TIME

I had my first panic attack in my sophomore year of college.

I started to walk down the steep stairs in the 400-student capacity lecture hall, and suddenly was overwhelmed with the fear of falling. My mind and body spun, as if I were in some weird postmodern snow globe turned upside down. I could not get a breath in, my entire body tensed up and my heart felt it would break through my chest. I was too embarrassed to tell anyone about this incident, and prayed that it was a momentary lapse of sanity, as I could not

logically make sense of it. However, the attacks began escalating, with the most random and innocuous things setting them off: escalators, staircases that were more than one storey high, sitting anywhere but at the edge of a row of seats in the movie theatre, being in large open spaces in public. None of it made sense, and I had no idea what was happening to me. I finally went to the clinic on campus that we all used. I tried to explain these terrifying episodes. They wrote my condition off as asthma, and gave me a prescription for an inhaler.

It was around this time that I first heard Joy Division. I had been a huge fan of New Order from my early teens. The soundtrack from the classic John Hughes movie *Pretty in Pink* had been omnipresent during my high school years; the album featured not one but two songs by the Mancunian band: the frenetic, anxiety-capturing *Shell Shock*, and the melancholic anthem, *Thieves Like Us*. Those two songs soon became not enough, and I ran out to buy the band's 1987 album *Substance*. I played the cassette too many times, as the tape became thin and brittle from overwear; I had to replace it on three different occasions before the advent of the CD.

New Order, while having a sheen of dysphoric angst in the driving electronic beats of Stephen Morris, Hooky's thrumming bass and Gillian Morris' bright, bubbling keyboards, still, on even the most disheartening lyrics crooned by Bernard Sumner, had a lightness and fun about it. There was none of that in Joy Division. This was dark, dense, unrelenting, no escape, no exit, out of control. It was exactly how I felt. I would pump the inhaler and desperately try to get air into my lungs to no avail. I felt so alone. There seemed to be no one who

could help me with what was going on. I did not understand what was physically happening to me in these everyday situations that previously I would not have even thought twice about. And yet the two things that I took for granted — mental and physical health — seemed to be snatched away from me. It was the most isolating feeling I have ever had.

It was only this music, that voice, those lyrics, that provided consolation. There is not a fun song in the entire roster of Joy Division. This void of any shred of joy or brightness was my panacea, as I felt equally hopeless. There is a bog of claustrophobia which runs throughout the band's song book — not just on obvious tunes like *Love Will Tear Us Apart* — but a continuous thread of thrashing, treadmill like close-down; instead of the wide open, palatial space between the notes of a New Order track, Joy Division — especially on songs like *Disorder*, *Digital* and *Dead Souls* — are narrow, confined yet frantic. It is an intensity of being trapped, which is exactly how I felt.

Over time, the attacks went away, only popping up once and again out of nowhere — but they had stopped controlling my life. I do not know how I would have survived that scary time without Joy Division. They were the only thing, the only voices, the only friends who seemed to share what I was going through, allowing me an unabashed three minutes while each song played through my Walkman, to not feel like a freak that was literally losing control.

## THE SECOND TIME

**M**y grandfather was the tough love, opinionated, gruff patriarch in our large family; but he was also the one person who I felt

completely believed in me. He taught me how to swim in the ocean, surf on decent sized breaks and propel down the side of my grandparents' three storey house. He told me to respect the ocean, and never turn your back on approaching waves. He encouraged me equally to be creative and artsy — he was an avid cartoonist, and would often send me comic strips of different scenarios of my life that I had told him about — while coming to all of my swim meets and cheering loudly from the side of the pool. When we found out he had terminal cancer, it was the worst day of my life. He was supposed to be indestructible — he had taught me to take on any challenge, to conquer life and push myself as far and as fast as I could. I watched tiny pieces of him, day after day after day, slip away, morphing from the strapping man who used to throw me over his shoulder into a tiny frail figure under a thin hospital sheet who needed help with even the smallest task — and knowing the whole time there was nothing I could do. He was dying right before my eyes, and no amount of deep breathing expertise, yoga, or booze could help me. I turned once again to my old friend Ian and his Joy Division cohorts. The balm of *Transmission* after a visit to the hospital, the salve of *Heart and Soul* when he had slipped into a coma and we decided to bring him home; *Atmosphere* an hour after I watched my grandfather draw his last breath. These were my weapons to combat the grief, the disbelief and the destruction of someone I loved.

## THE THIRD TIME

I decided to do it — to sell everything I owned, leave behind the security of a well-paying job, and say goodbye temporarily to all of the people I loved. I was going to fulfil a lifelong dream of living in England and getting a PhD. There was only one huge problem — I had no idea what I was going to write about or study. The whole idea of a PhD is to look in-depth at a specific topic, and create a new body of work and research that has never been considered. I am a staunch Generation Xer — one of our core values is that everything has been done, used up, traced and remodelled before we even came of age; those baby boomers snatched our possibilities of rebellion with their Summer of Love, then did nothing with it, as they slipped into the coke-guzzling yuppies of the eighties. So what was I, a girl from Santa Cruz, California, going to discover or uncover that no one else in the entire history of scholarly knowledge had ever thought or looked at before?

This predicament haunted me, as I held garage sale after garage sale to sell all of my personal items; as I packed boxes, sorting beloved possessions to store, ship or give to charity; as I walked into my first meeting at my new university in London, where everyone went around in a circle, proudly announcing their chosen topic, giving painful and often unnecessarily pompous details about their projects. As the turn to talk drew closer and closer to me, I quickly mentally flipped through all of the ideas I had filed away in my mind for possible topics. Generation X itself? Hadn't Douglas Coupland pretty much done that to death? How about swimming? Too broad. You are supposed to pick something that you simultaneously love enough to keep your interest and enthusiasm for the years it takes to complete the PhD; but this amazing, intriguing topic had to simultaneously be something little written about or discussed. As a popular culture

junkie, the very description of pretty much everything I liked had already been picked apart and analyzed ad nauseam. As my turn to speak finally came, I decided to just see what answer popped out when my turn came. 'Joy Division,' I said. Huh? Where had that come from? It was as if Ian Curtis' spirit had somehow manipulated my mouth, brain and vocal chords at that exact moment and formed those words. Everyone stared at me — what? This did not sound deeply scholarly; I had not mentioned a single random philosopher nor dropped any obscure German theory into my topic's description.

This simplicity somewhat haunted me; I heard through the gossip grapevine that others in our department, including faculty, did not think I was looking at a serious enough or important enough topic to necessitate a PhD. However, when I reflected on my own journey with the band, there could not be anything else more profoundly, singularly significant to me. Joy Division had become my religion; what I turned to in times of fear, challenge and sadness. Because of their amazing qualities to pull me through even the seemingly most impossible of times, I therefore also listened to them when I was happy and celebratory, as they reminded me that survival does happen. If a potential boyfriend did not like them, I knew we would have no future together. I had been to Ian Curtis' grave more times than my own beloved grandparents'. All of these aspects reflected traits and behaviours of secular worship. Ian was my God, the songs my *Bible.* I decided to look at how and if other people behaved the same way: if Joy Division, Ian's grave in particular, facilitated a similar place of holiness in other lives.

For part of my doctorate, I decided to go to Ian Curtis' grave on the same day of the month every month for a year. While there, I would document the trinkets, tributes and trash that people had left at his grave. This formed the foundation of my PhD, which examined ideas of images, authenticity, and branding in a 2.0 world.

The topic of Joy Division as a specialism, a subject which literally spontaneously and organically sprang to my lips that one fateful day, has proved to be an incredibly good choice for me. Scholars who know and appreciate Joy Division immediately want to talk about my work. More exciting, regular folks who are not academics also love discussing the band. It has allowed me to meet people all over the world, and hear how and why the band has affected them, and why this is important. I have made lifelong friends through Joy Division, and have been able to introduce the band to folks who may have never heard of them. I got a PhD, a full-time permanent academic job, three book deals, hell, I even met my English husband because of Joy Division. The importance of Ian Curtis to me has been all-consuming and omnipresent; the ideas of Englishness and the modern legends which surround the group and that moment in Manchester indelibly influential.

I do not know if there will be a fourth, fifth or endless times that the band will influence or change the course of my life. I do know that I am endlessly thankful to Joy Division and those who helped make their legend — Kevin Cummins, Rob Gretton, Martin Hannett, Paul Morley and Tony Wilson — for the varied roles the band has played in my life. I will forever be a fan, and forever be in their debt.

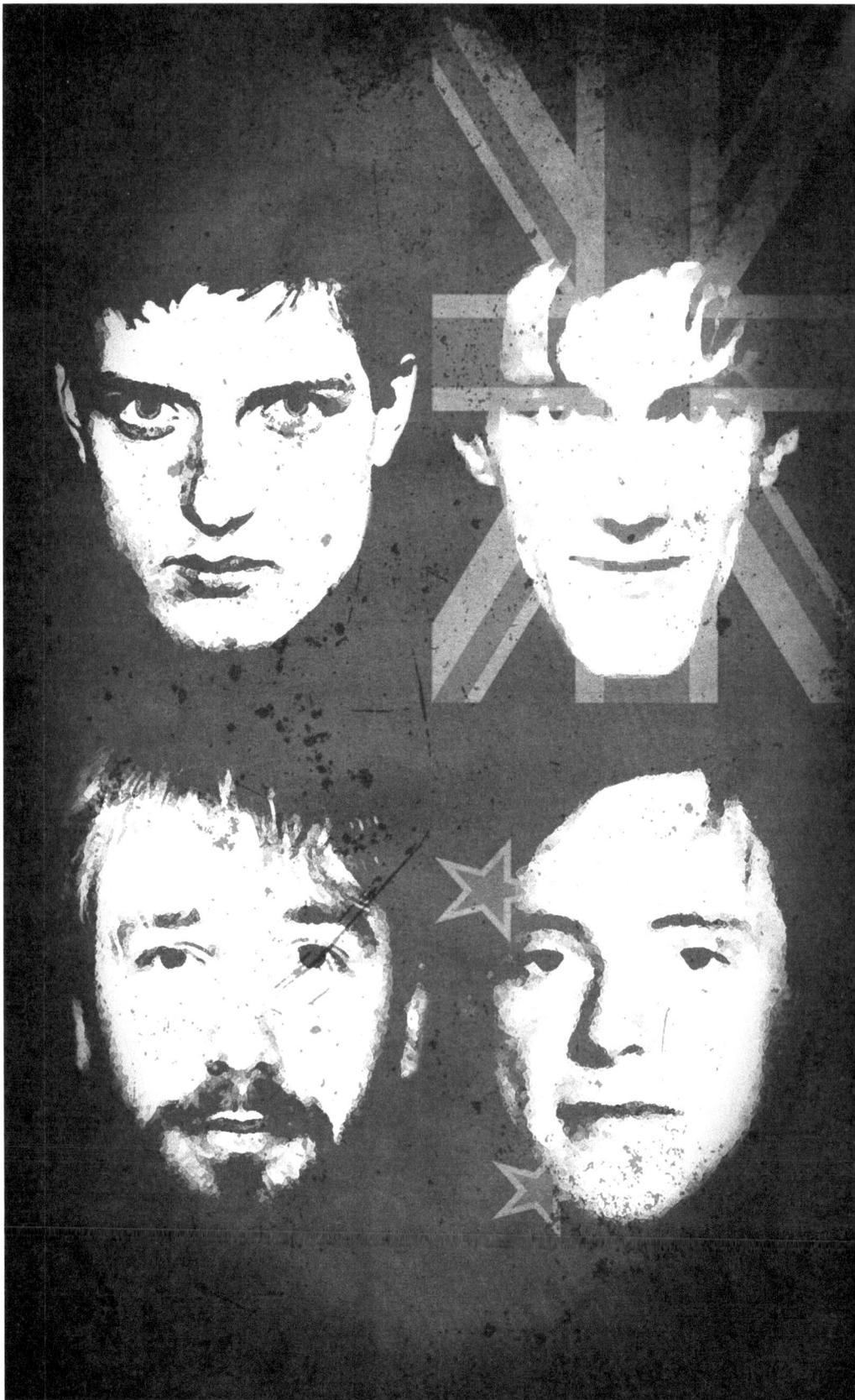

# TRANSMISSION IN THE COLONY

## On exported Englishness and the secular religion of the axis mundi

### MIKE GRIMSHAW

In the age of television, Joy Division erupted completely unexpectedly from the radio. There was no Ziggy moment such as Dylan Jones writes of seeing Bowie on *Top of the Pops* in 1972 whereby: 'Suddenly, we all had a shared mythology, one we could call our very own.' For my generation down here in New Zealand, this would not occur for another couple of years when suddenly, there on the alternative programme *Radio with Pictures*, then so quickly afterwards on the mainstream *Ready to Roll*, appeared Morrissey and his gladioli being a charming man; a Bowie for a new generation at a time when both Ziggy and the Thin White Duke had got fatter, older and gone not to Berlin but American mega-stadium-mainstream. Yet our openness to the Smiths, our openness to all that came out of England was strongly influenced by Joy Division.

In 1981 *Transmission* hit number two on the New Zealand charts followed by *Love Will Tear Us Apart* and *Atmosphere/ She's Lost Control* both charting at number one. This was no short foray; *Transmission* stayed in the charts for ten weeks, *Love Will Tear Us Apart* for twenty-eight weeks and *Atmosphere/She's Lost Control* for twenty. Joy Division suddenly, quickly, became an aural presence, and for most of us Joy Division was a singles band as the weekly top twenty played on radios across provincial New Zealand.

Age is an important element for recounting a personal history about a band. We forget just how long ago this was. I was born in 1967, and was only fourteen when Joy Division broke in the local charts. We also need to remember this was the age before MTV, so most music was aural not visual. When Joy Division broke

down here, they were a band heard but not seen; there were no performance videos, they were absent; there were images in music papers, but they were not in large circulation; so the videos of Curtis in full action didn't really circulate until after his death. What we had was their sound on the radio, text about them in imported *NME*s that were months out of date by the time they arrived by boat and then shipped in small quantities around the country, and black and white photos.

It is this combination that made Joy Division special because we could hear them but not see them; they truly were an unknown pleasure in many ways. When we did see them, they were static and so decidedly, determinedly, ordinary looking. However, this meant they were accessible. Even more so for almost all of us, the fact was that Joy Division occurred after they had ended. Ian Curtis was dead, and New Order was in its infancy. This meant that *Movement*, perhaps the real Joy Division album for many of us, the one we could own on cassette, the album of a band moving forward, became our focus. How do you overcome tragedy, death and despair? — by movement. You take the sound and remake it slowly. So we had the singles of Joy Division and the albums to come of New Order. In 1983 *Blue Monday* charted down here for seventy-three weeks, and in the process we were taken into an engagement with black dance music that we thought we had left behind when we rejected disco in favour of post-punk. In all of this, Manchester became a focus. It was 'Up North' that we looked to, from over 12,000 miles away. Our latitudinal antipodes might actually be Spain and the south of France, but in

temperament and history, colonial history, family history, it was dreaming of England once again, and in particular, Manchester.

My grandfather came to New Zealand from Bolton, emigrating in the 1920s and dying in the 1930s after contracting meningitis in an unemployment relief work camp. My father, New Zealand born, never got to England, dying too young before he could do his hoped-for pilgrimage of English cricket grounds. So, on the one hand I grew up, as many New Zealanders did, with an orientation toward England. Our books were mainly English, our television, such as it was with two channels, was overwhelmingly English. We had *Match of the Day* each Sunday, *Pot Black* in the evenings, *Coronation Street* weekly. And yet there was always a tension, a tension not only that of 'down here' and 'back up over there', but also of 'down here' and the other 'up there' of America. If our colonization had been by the British, if so much of our life and culture was infamously described as still being England in the 1950s, if the joke was that on arriving in New Zealand visitors were told to 'put their watches back twenty years' there was also now America looming large in our consciousness, especially the America of popular culture, the music of America. For America was modern, it was carefree: it had California, it had sunshine and it had sex. America was cool while England was chilly. England was your parents while America was your cool older cousin.

The light down here is bright, and how to express this light is a theme in our cultural nationalism. We were and are told repeatedly we are not English, and this was no longer the farthest outpost of England. But our attempt to be independent, to

create a national identity in music, was too often to recolonize ourselves, uncritically, via America. But America was too often disco, schmaltz, the Eagles; all over radio and television America was mainstream fare and the commercial, bland, imposed, almost inescapable soundtrack to our lives. Even in my small village in the provinces, as far away culturally from New York as you can imagine, we had to learn the Brooklyn Shuffle as eleven and twelve year olds as a 'contemporary' alternative to folk dancing in our dreaded Phys Ed classes. Disco was everywhere. This was a classic example of cultural colonization: a forced attempt to learn to dance like John Travolta in *Saturday Night Fever* — a film we were all far too young to see, let alone understand. If not disco then it was the Eagles, or the mum and dad-friendly Europop of Abba. Or the Beatles, who made the sixties sound increasingly like music hall, everywhere on provincial radio in one-station areas, on the dreaded easy listening rotations that drive regional adolescents crazy. The chance of anything different being heard was limited by choice. Alternative music truly was alternative back then. Unless something unexpectedly crossed over into the charts, you were limited by what was on sale in the mainstream record shops. Because anything alternative had to be imported compared to the local pressings of the mainstream choices, alternative music was expensive and rare. This is why the single was so centrally, culturally important. Joy Division were, for most, a singles band because this is how they were heard and this is how they were and could be accessed. Furthermore, as a singles band, they could be played on the radio.

Radio play created a community, the possibility of access, in a contrast to the way that albums tended to circulate in a sectarian manner.

So it was against this cultural banality that we first heard *Transmission*; a song about the disparate community of individual listeners united by music. Radio provides an aural community of singularity open to be struck by subversive wonder. *Transmission* sounded like nothing else: it is the sound of post-industrial nihilism and its overcoming, albeit temporarily. This is not dancing to the album, not dancing to the DJ, not dancing in the disco. To dance to the radio is a call for all those who are in isolation listening to the radio as the means to engage with a wider world. To listen to the radio is to be open to the event of the unexpected, open to the eruption of difference into our lives. Radio is potentially revolutionary and subversive. Radio, in those pre-internet days, took you out of your context and gave you access to the wider world.

Just consider what happened. In a small village in the deep southern Pacific, I heard and connected with the sound of post-industrial Manchester in an emotive, physical, redemptive fashion. My mind and body were colonized anew, a colonization that continues to this day. We need to remember that colonization, especially cultural colonization, can be a transformative act that opens up new possibilities beyond the existing options and limitations. Via Joy Division on the radio, England and a different tradition of Englishness became an accessible alternative of difference. These three singles became a constituent core to my self-identity, to my being, in a way I

cannot fully express. In simple terms, I was converted to the possibility of difference, to the possibility of an alternative vision and experience of life. Here was the possibility, for all who felt — if unable to articulate it — in need of an alternative to the tyranny of distance and suffocating banalities of mainstream conformity. This was not a passive, or purely mental, possibility. To engage took physical form, driven by the mechanistic melody of Hook's bass line and Morris' drums, the original post-punk form of drum and bass. To dance, dance, dance to the radio meant, unbeknown to ourselves, imitating in our own way the jerky movements of Ian Curtis. There could be no shuffle, no groove, nothing cool or smooth as our adolescent, already-awkward bodies were possessed in our bedrooms and living rooms, by the sound of Joy Division. Our ears, our minds and our bodies were colonized by awkwardness, by agitation, by a fuck-you, can-do, will-do attitude.

What Joy Division symbolized was in effect 'punk' and a countercultural 'Englishness' for the generation too young for punk. I can still remember the day when the Sex Pistols interview with Bill Grundy played on the television news in December 1976. Sneering, spitting, swearing, they were unlike anything an almost-ten-year-old boy living in a small country village in the South Island of New Zealand, in rural 'arcadia', had ever seen or heard. The news, to give a context regarding this threat to civilization, then played some brief images and sounds of punk that were completely different to the generic Top Forty pop-rock I'd heard snatches of on TV and radio, or the classical my parents listened to. There was

something here, something that seemed so foreign to where and who I was. While at school the next day there were those few of us who were precociously excited and delightfully appalled at the same time, for most of my contemporaries this was a non-event. It is also important to remember that for most of us who are now approaching fifty, in the years between the Pistols interview and the event of Joy Division on the local charts, punk didn't really make an impact. It was primarily newspaper and TV images of performance punks: those who dressed to 'be punks' with Mohicans and safety pins, gobbing and union jacks, tartan pants and sloganned leather jackets. For most of us my age, our early adolescence was still spent in a soundtrack to America.

So then in 1981, at a time when music seemed to have gone into saccharine overload, there came, through some twist of fate, the song that revitalized the youth of this country. This was a sonic and countercultural bomb going off. Most of us were reduced at this time to listening to the New Zealand Top Twenty countdown to try and keep abreast of what was around. This was a rare alternative to the limited rotation available on provincial radio stations; *Transmission* had struck some of us, this was still a small cult of the converted. The event of mass conversion was yet to come. Then one night, through the small transistor radio, came the haunting, gloomy, sonic shock of *Love Will Tear Us Apart*. Suddenly we had a sound, a song, an anthem. The words were mumbled but the feeling was intense. The country seemed brittle. We were becoming aware of politics through the nightly TV confrontations of

a government under pressure. There was also, most damagingly and politicizing, the almost-civil-war of the violent nationwide protests against the tour by the apartheid-state South African rugby team. The Cold War, even down here, seemed all too fated to become hot. We seemed shunted into a country that had lost its Golden Weather. Amidst all this, these gloomy, suicidal, post-punks from the North of England, with their non-video videos gave us a counter to the prevailing American 'happiness' that seemed so prevalent. Obsessed with the likely fear of nuclear destruction before we were thirty, this song of longing, romanticized despair became a soundtrack to our lives. Living in the southern Pacific we wanted to be English; middle class, we wanted to be working class; living in rural light, we desired urban gloom. Angst had arrived.

Remember, and this cannot be over-emphasized, this was the time of disco and American AOR (Adult Orientated Rock). Our cultural colonization in music was increasingly American. There was also the beginnings of what can be termed a Pacific sound, a type of local soul that lacked the ecstasy and danceability of what had yet again occurred 'up there' with Northern Soul. Down here was what could be later termed Poly-soul, a Polynesian soul music that was slower, more languid, not the music to dance to on speed but to shuffle to on weed. It was a laidback lazy groove for those who wanted to believe, were content to believe, they lived in the bucolic South Pacific. But for adolescents who thought, adolescents who read, adolescents who felt the constraints of provincial life, we wanted and needed more. We didn't want to be white pseudo-Polynesians grooving happily in the sun. We didn't feel we lived in the South Pacific. We were looking for a place to orient ourselves toward, an axis mundi. A place, a sound, an identity we could bind ourselves with. A place we could re-read ourselves to. I didn't understand this at the time. It is only much later, as I worked in the field of religious studies, that I really understood how popular culture, how music, acts in this way as a secular religion in both sense of the primordial words: religare to bind; relegere to re-read. Joy Division turned us back to England, to England as a sound and claim of countercultural identity and rebellion. This was the sound of the North, of the North that many, my grandfather included, had emigrated from in search of a better life. Here was the sound of the life left behind. And yet, listening to this in the midst of the pastoral beauty of small town, South Island, New Zealand, I, like many others, began to be recolonized by the transmission of sound. Manchester became our axis mundi, a sonic capital of geopiety and the key to a new community who dreamed of an England so different to our own location.

The New Zealand novelist and critic CK Stead wrote of 'colonial realities':

*There were two realities — the one we saw and touched, and the one you read about — and it might be said that each was in some degree compromised by the other.*

Joy Division recolonized the post-colonial youth by transmission: an alternative Manchester that became the new reality, a reality of affect, the one we heard and then read about. It returned us toward England, a re-colonization that has never really ended. Geraldine where I then lived, where I consumed and was

consumed by Joy Division was, and is, a backwater, a combination retirement and farming centre: very solid, stolid and conservative. Always described as 'delightful', 'pretty' and 'picturesque', its essence is summed up by one guidebook as 'studded with trees by the early settlers in their dream of quite literally transplanting England to the Antipodes'.

After WWII, the returning poet Denis Glover, in his poem *Home Thoughts* stated in its concluding stanza:

> *I do not dream of Sussex downs*
> *Or quaint old England's quaint old towns:*
> *I think of what will yet be seen*
> *In Johnsonville and Geraldine.*

This held in a nascent New Zealand cultural nationalism for almost forty years until we knew just how little would be seen in Johnsonville and Geraldine. So we did begin again dreaming of England, but not of Sussex and not of quaint towns, for too often we lived in antipodean colonial attempts to replicate such pastoral dreams. We dreamed of post-industrial Manchester, of late-modern urban decay. And yet Manchester, its experiences, its history and people could not have been more foreign. But Manchester was the sound of modernity, the sound of urban life, the tension between that post-industrial haggard despair of *Transmission* and the sonic, electro-symphonic wash of *Love Will Tear Us Apart* or *Atmosphere*. We also need to remember that the look of Joy Division was central to their impact. They looked nothing like pop music, they looked nothing like the stereotypical punks who were already dated, there was no clichéd

mod-revivalist uniform of suits, no new romantic excess. Yet there was this edge, this sense of young men determined to do their own thing, dress their own way. A provincial expression of independence that was decidedly English. In response, a whole generation of antipodean males turned to what we called op-shops, the secondhand clothing charity shops and this meant middle class kids in the deep southern Pacific began to dress like they were working class, post-industrial post-punks from Manchester. We recolonized ourselves not just in what we listened to, but how we dressed, what we read and our politics increasingly too were lived 12,000 miles away in reference to Thatcher and the miners' strike. *NME*, late though it was, become a sacred text we read avidly for divinations. Joy Division was gone, Curtis was dead, but in the colony our heart and soul had been recolonized by Manchester, by the North of England.

Ian Curtis became our sacrificial figure, our generation's Jim Morrison, a type of shaman, consumed by his vision, twisting with the power and terror of what he saw, taking us on a sonic journey of the soul through the tensions of late-modern life. Joy Division were of course never just Curtis, but the segue into New Order that occurred at his death meant that in many ways he was Joy Division. And he tied us to a particular time and place, a vision of articulate, awkward Englishness, the embodiment of a young man with too much to say and a body that just wouldn't do what it should to be cool.

While we might talk about the cultural significance of the album as a work of art and vision, we forget that what we immediately respond to is the single. Pop music never meant, can never mean as much to us as it does when we are adolescents. As I have grown older, my record collection has been given away, the tapes lie in boxes in the garage. But I still live recolonized by England, an England of cultural, literary and artistic production, an England of images, ideas and sounds mediated through my location down here in the deepest southern Pacific. Joy Division made me realize that in a colony one is always a colonist, one is always recolonized and that there is always a centre and a periphery. To live on the periphery is however a point of privilege. I could listen to Joy Division without issues of north and south, without class divide, without the context of post-industrial decay. I can partake of England and Englishness in a fashion that allows me to overcome all those internal divides, all those prejudices and affronts that bedevil the English English. Joy Division are an English band,

an English sound and an English event; a Manchester sound, a Manchester event, a Manchester band that could colonize me and in return be remade, relocated in my dreams and hopes, that provided a possible alternative, an aural roadmap out of a southern Pacific, provincial adolescence. It made me realize that place is itself as much a state of mind as it is an event of the body.

What is most important thinking back over more than thirty years is that I could listen to and encounter Joy Division as a singles band; as sound that was immediately accessible and available via the radio. The single is democratic in a way the album too easily and quickly becomes sectarian. The single is a demand to be heard, a proclamation to everyone of accessibility and intent. Joy Division's singles were a statement that this is now, this is Manchester and here is the sound of being young in post-industrial regions. And yet what made them accessible, outside of Manchester, outside of England, was their proclamation that there is still hope in awkwardness, possibility in despair. We carry the singles in our heads, in our memories in a way we never can do with the albums. Because of the radio, the singles are a shared experience, a public, cumulative religare and relegere, whereas the album is too often a retreat from sociability. For many, listening on the radio, that final single of *Atmosphere* was both an unplanned, posthumous funereal reflection and the possibility of being moved to our marrow by sonic sculpture. It is a slab of sound that still holds its transcendent promise across the years. It is here that Joy Division truly created a secular sonic religion, a hymn to place and awkward, cussed Englishness.

FACTORY
FRI. SEPT. 29
ROYCE RD. HULME
JOY DIVISION

SALTEC ENTS
presents a
GRAND XMAS BALL
FEATURING
ED BANGER
JOY DIVISION
FAST CARS
FRIDAY 1st DEC. 1978

TICKETS 75p from Union Office
£1.00 ON THE DOOR
8 - 12          DISCO          LATE BAR

SHIMMY....

JOY DIVISION - FACTORY - JULY 13

KIM·PHILBY·REAPPEARS
JOY DIVISION - A CERT
AIN RATIO - SECTION 25
NEW OSBOURNE – FEB
FAC FOR CITY FUNDS
(£1¼)

LIVE ON STAGE
EMERGENCY
RISK
JOY DIVISION
PLUS SURPRISE SUPPORT
Plus Ian Jameson
AT
THE MAYFLOWER
Saturday May 20th

# CITY LIMITS

## Why Manchester's creative spirit died after Joy Division and Factory

### MARK BRODIE-WRAY

For twenty years, Manchester was the greatest music city in the UK, perhaps the world. It produced Joy Division, the Fall, New Order, the Smiths, Happy Mondays, the Stone Roses, Oasis and many more of the most influential bands in UK music history. There may be arguments over the precise definition of this golden era, but few are likely to argue that it existed, or that it produced a run of bands rarely, if ever, matched by one city.

Many would say this era was instigated in 1976 by the famous Sex Pistols concerts at the Lesser Free Trade Hall, which most of Manchester's later music greats (and Mick Hucknall) attended. I suggest it began in 1978, the year that saw the release of Joy Division's *An Ideal for Living* EP, the debut release by the first truly iconic Manchester band. The same year also saw the recording of *A Factory Sampler*, and thus the beginning of the Factory Records story. Not all the finest bands

of this era, or even the majority, were on Factory of course. However, Factory, and Tony Wilson in particular, were so big on self-promotion and the promotion of Manchester, that it feels like Manchester's golden era and the Factory story are irrevocably intertwined. Similarly, to me, 1997 was the end of this era, as it saw the closure of the Haçienda, bringing the Factory story to an end a few years after Factory Records itself folded. Also, 1997 saw the release of Oasis' bloated *Be Here Now* which made us realize that Manchester's last 'great' band might not be so great after all.

I moved to Manchester in 1998, when by any reckoning the golden era had ended. Of course, I didn't know it at the time. Music had been my inspiration for moving to Manchester. Bands played there more often than any other city in the North of England, but it wasn't only that. Like the narrator of LCD Soundsystem's *Losing My Edge*, with his increasingly

ridiculous claims of being at music's most pivotal moments 'I was there in 1974 at the first Suicide practices in a loft in New York City… I was there in the Paradise Garage DJ booth with Larry Levan,' I wanted to be there. I couldn't travel back in time to be at the early Joy Division gigs at Rafters or the Electric Circus. I couldn't see the Smiths or Happy Mondays before they made it big — but I could be there for the emergence of the next great Manchester band, whoever they might be.

However, in the twelve years I lived in Manchester, that next legendary band never appeared. I did go to many amazing gigs from non-Manchester bands. I also discovered several Manchester bands I enjoyed. (The Answering Machine, I Am Kloot and the Earlies were personal favourites, and Everything Everything, Elbow and Lamb were among those mentioned by contemporaries interviewed when discussing that time period.) However, whilst those bands were successful to one extent or another, none had the impact of the golden era bands. They will not inspire legions of devoted fans thirty years after their heyday as Joy Division or the Smiths do. They didn't change the course of UK music as the Stone Roses or Oasis did. So I started to wonder why. Why did Manchester produce so many great bands in the Joy Division and Factory era, but none since? Was it just good fortune, a run of luck that was bound to end sometime, or were there reasons for the decline?

My perspective is that Manchester's obsessive devotion to the golden era bands was, at least in part, responsible for holding back new talent. Manchester had never been exactly shy in boasting

of its musical heroes. Go to any indie disco in Manchester in the last twenty years and you could be fairly sure of hearing half a dozen Stone Roses songs, as well as *Transmission, Blue Monday, This Charming Man* and any number of other Manchester classics. Music (and football) were at the top of the list of reasons that Mancunians would recite as to why their city was superior to my own home city of Leeds. Over my time in Manchester, however, this braggadocio became increasingly commercialized. Noting the Beatles' boon to the Liverpudlian tourist industry, Manchester's institutions and businesses began to use its musical history as a promotional tool, to attract visitors, students, residents and businesses. Guided tours and walks appeared showcasing famous Manchester music locations, including a Joy Division tour visiting everywhere from Ian Curtis' childhood home to the former Factory office on Palatine Road. Manchester's museums and galleries displayed Peter Saville's Joy Division record sleeves and other music memorabilia. The Haçienda was demolished, and in its place now stands a luxury apartment building named… the Haçienda. There was even a café named CAF51, after FAC51, the Haçienda's Factory catalogue number, although it didn't last so long.

All of this promotion seemingly worked. During the interviews I conducted with contemporaries who moved to Manchester post-1997, many mentioned music in one form or another as a reason for moving to the city, with Joy Division and the Haçienda mentioned more often than any other bands or venues. A 2011 University of Bournemouth study on UK music

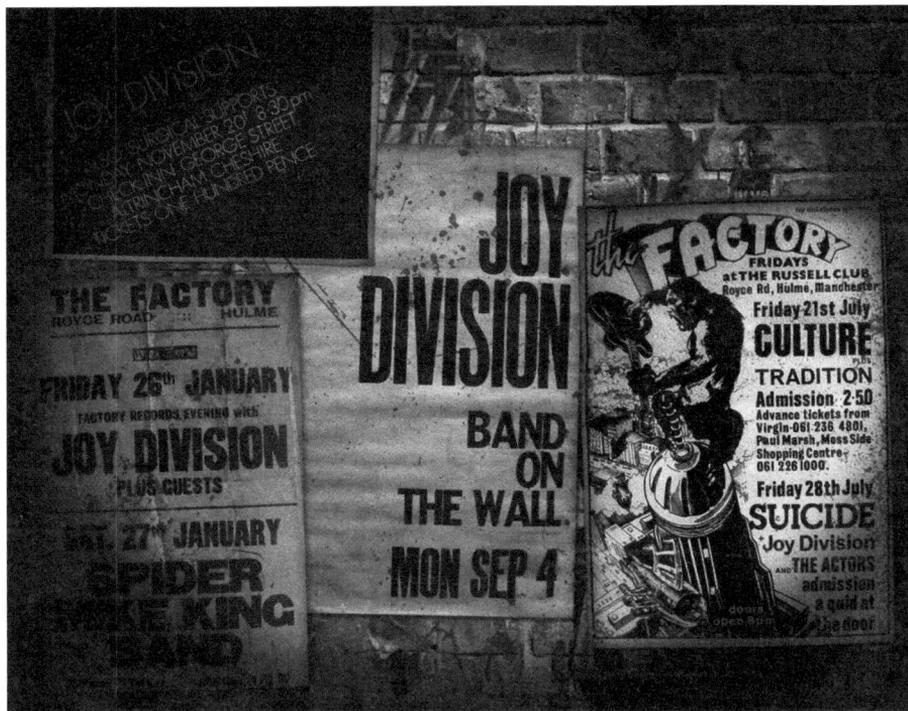

tourism is also instructive, highlighting Manchester's role in the North West of England becoming the biggest beneficiary of 'music tourism' outside London. However, Manchester councillor Mike Amesbury commented on the report: 'Manchester needs to be careful, we need to strike a balance between the historical and the innovative...We don't want to be like Liverpool, overegging something like the Beatles. They are fantastic, but Manchester doesn't want to live in the past.' Yet, to me, this is exactly what has already happened.

Turning Manchester's musical history into tourist attractions and museum exhibits began a process of ossification. It confines Manchester music history to a short time period, a small number of bands and personalities to the exclusion of all others (and yes, I recognize the irony that I am doing much the same thing). The history of Manchester music becomes a new Mount Rushmore, with the faces of Ian Curtis, Tony Wilson, Morrissey and Marr carved into stone as heroes, even deities in the case of Curtis and Wilson. The problem with this is that Mount Rushmore doesn't change, is never added to. Manchester's musical legends have been defined, set in stone, and the implication is they will never be matched. There is no room for newcomers.

Wilson himself is partly responsible for this process, as he was writing the legend of Factory and Manchester as he went along, culminating in the book and film 24 Hour Party People. He did at least undercut the mythologizing with self-depreciation, a prime example being the promotional poster for 24 Hour Party People, describing Ian Curtis, Shaun Ryder

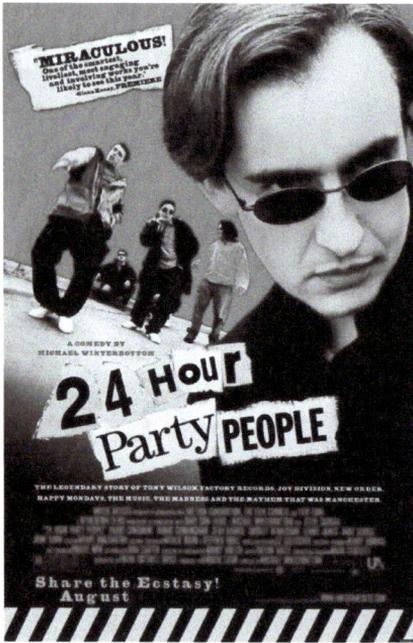

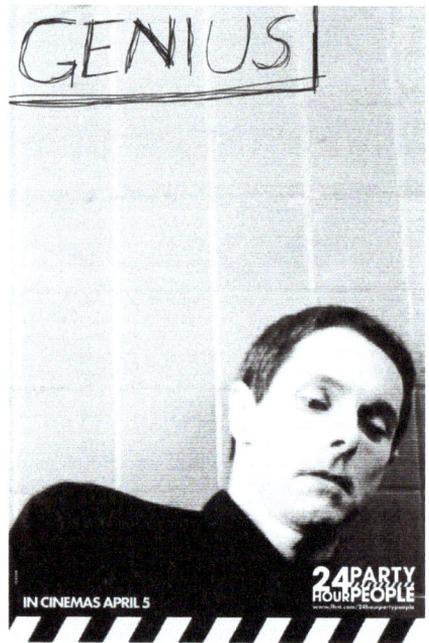

and Tony Wilson as 'Genius', 'Poet' and 'Twat' respectively. When Wilson died in 2007, there was no one left to prevent his posthumous deification, as had happened to Ian Curtis before him. There has even been a recent attempt by Joy Division fans to purchase Curtis' former home, to be kept as a shrine (provoking mixed reaction from the other Joy Division members, Bernard Sumner describing the attempt as 'a bit ghoulish and… it's a bit of a monument to suicide as well'). To claim Curtis or Wilson have been deified is not to claim they have become entirely immune to criticism, but death has brought with it the tendency to magnify their achievements and minimize their flaws. Unlike Morrissey, for example, they have not been around to remind everyone of their mortality by making provocative/ ridiculous comments (or be deliberately misinterpreted by the media, depending on your viewpoint).

The impact of this deification and hero-worship of Manchester's past musicians on later Manchester bands is not hard to imagine. 'How can we be expected to emulate these legendary figures?' they must consciously or unconsciously wonder. Oasis titled one of their post 1997 albums *Standing on the Shoulder of Giants*, but during my time in Manchester, it seemed that bands were standing in the shadow of giants, afraid or unable to match the achievements of their predecessors. Back in Joy Division's time there were no such bands to compare themselves to, 'Bands came to Manchester but they didn't really come from Manchester,' so there were no limits to what they could achieve.

The ever-increasing promotion of the golden era Manchester bands also had a strange impact on the members of those bands still inhabiting the city. To become a tourist attraction and part of your city's history in your own lifetime must be

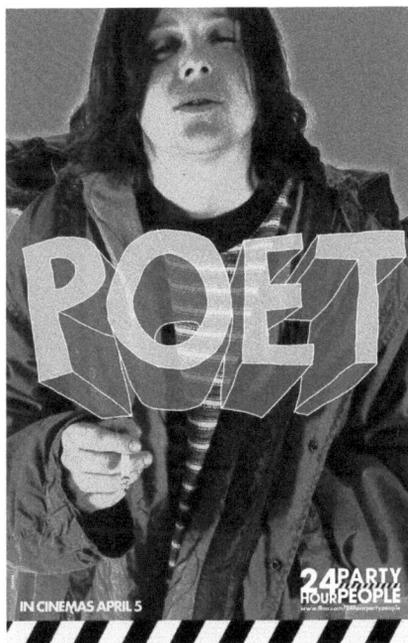

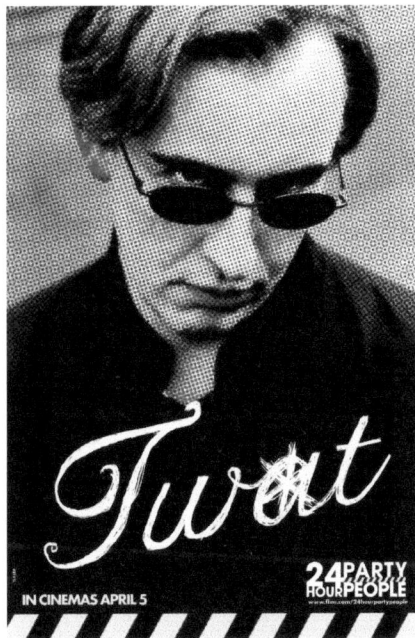

a disconcerting experience. Some, like Curtis and Wilson are no longer with us to experience this, and others like Morrissey have long since fled the city and the country. However, many others remain. Having heard the legends of Joy Division, Factory and Manchester music so often during my time there, it was incongruous to run into characters from those tales during the course of my day to day life. Bez, confused, wandering the aisles of a Chorlton supermarket. Andy Rourke playing records in the basement room of a Fallowfield pub. Alan Erasmus as a friend's landlord. It was as if characters from fiction had come to life and started populating my real world.

These individuals now had to choose whether or not to profit from the suddenly more lucrative legacies of their former bands, and, quite understandably, most did. Peter Hook toured as a kind of Joy Division covers band named Peter Hook and the Light, playing Joy Division's albums in full, as well as popping up in Manchester nightspots DJing 'Haçienda classics'. (Laudably, he has more recently announced he is using the same band to stage a concert to raise funds for an epilepsy charity and to restore a church in Macclesfield, Ian Curtis' hometown.) Other bands reformed, either intermittently and underwhelmingly (Happy Mondays) or rather more lucratively (the Stone Roses). All of this added to the impression that Manchester's music scene was focused more on the past than the present. Manchester's 2015 'Summer In The City' festival featured Noel Gallagher, Johnny Marr and the Charlatans among its headliners; but newer Manchester bands were conspicuous by their absence. It is hard to avoid the conclusion that the transformation, deliberate or otherwise, of Manchester's music scene into an

idealized past rather than a living, breathing present, has impacted on the motivation and opportunities for younger bands.

A second explanation for Manchester's musical decline is less directly about music itself. Manchester, especially during the earliest years of its golden musical era was, by most accounts, a grim, disheartening place to live. Its growth during and following the industrial revolution had long since come to a halt. The damage and destruction wrought by WWII had in many cases never been undone. Empty factories, abandoned industrial areas and high-rise flats dominated the drab landscape. Bernard Sumner recalls, 'I don't think I saw a tree until I was about nine' and 'You were always looking for beauty because it was such an ugly place'. Unemployment was high; peaking at over fifty per cent in certain areas of Manchester by the mid-1980s. Joining a band was a way of escaping, or at least dreaming of escape. But more than that, the environment impacted directly on the music itself. This is especially true of Joy Division, and much has been written on how Manchester, as a city, influenced their sound. Joy Division's spatial circular themes and Martin Hannett's shiny, waking dream production gloss are 'one perfect reflection of Manchester's dark spaces and empty places' as journalist Jon Savage describes it. The impact on Ian Curtis' lyrics is less remarked upon but also apparent in the 'dark streets' and 'city limits' of songs like Interzone. The poverty and lack of opportunity in Manchester influenced other bands of the golden era in a multitude of ways,

but the influence was always there. The songs of the Smiths are littered with direct, mostly negative, references to Manchester, the 'humdrum town'. The Stone Roses, Happy Mondays and Oasis reacted defiantly, with swagger. They wrote joyous, drug and alcohol fuelled escapist anthems to show that it would take more than their bleak environment and a lack of jobs to keep them down.

But during my time in Manchester, the city changed massively. An IRA bomb in 1996 had devastated part of Manchester's city centre, but also led to its redevelopment and spurred economic growth in the area. The 2002 Commonwealth games brought new stadia, facilities and improvements to the public transport networks. Regeneration projects began to reclaim previously abandoned areas of the city, especially in the north and east. Luxury flats and offices sprang up with frightening regularity. The BBC moved a large part of its operations to Salford in 2011. Whilst the recession of 2008–09 onwards did slow Manchester's regrowth, it could not be stopped. Manchester has, once again, become an economically vibrant city, awarded unprecedented autonomy and spending power by central government and in many people's eyes displacing Birmingham as England's second city. This is all a very good thing for Manchester. But what does it mean for Manchester musicians? Architecture writer Owen Hatherley certainly believes the impact on Manchester's cultural life has been negative: 'Regenerated cities produce no more great pop music, great films or great art than they do industrial product. What they do produce are property developers.'

This chimes with my own experience of the changing city. Manchester has become cleaner, brighter and wealthier, but perhaps more sterile, less interesting. Whilst the motivation to escape poverty and ugliness may not have disappeared entirely, it is certainly less prevalent. 'Is it worth the aggravation to find yourself a job when there's nothing worth working for?' was one of Oasis' more memorable lines. 'Is it worth the aggravation to find yourself a well-paying job in one of Manchester's many creative industries?' does not have quite the same ring. Would the great Manchester bands still have formed if economic circumstances had been more favourable? Would they have had the same motivation to succeed?

The close correlation between the end of Manchester's musical golden era and the beginning of its economic rebirth is suggestive, if not exactly conclusive. It is certainly true, however, that a lack of alternatives can be a powerful motivator in many spheres, whether cultural, sporting or even criminal. Just read the autobiography of any working class musician, footballer or gang member for evidence of that. Tony Wilson has claimed that Joy Division went on stage 'because they had no fucking choice', so perhaps they would have still formed and succeeded even if they had existed thirty years later in the new, more prosperous Manchester. It is safe to say, however, that without the influence of Manchester's harsh, industrial landscape they would not have sounded like the Joy Division we now know.

My view, developed during my years in Manchester, is that both the commodification of Manchester's recent

musical history, and its economic revival have contributed to the decay of its creativity. My Manchester never did quite live up to Tony Wilson's dream of becoming an alternative cultural centre to London, a rival on equal terms. The capital city still dominates the UK's cultural landscape and creative types still tend to migrate there despite physical location being less important than ever in this digital age. This is not to denigrate Manchester. It is a wonderful city to live in, and residents in the years 1997 to 2015 interviewed for this chapter spoke glowingly of their time in Manchester and their musical experiences there. However, Nick M's (fanzine editor and gig promoter) statement that 'my love of Manchester music is less about the bands the city's produced, and more about the scenes it has helped to foster' is fairly typical. Nobody claimed that a great Manchester band defined their time in the city, as past Joy Division or Smiths fans may have said, or that they had lived through a musical revolution like Madchester.

I never did achieve my ambition of being there for the birth of a great band, but my times in Manchester were some of the happiest of my life, and most of my formative musical experiences took place there. A piece of my heart will always belong to Manchester and listening to any of the city's great bands, and most especially Joy Division, will always transport me back to my time there, and the unknown grey streets of Manchester past. Manchester will always be one of the UK's great music cities, but unlike that glorious period of 1978–97 it may never again be the great music city.

# NEW DAWN FADES

**JAMIE STEWART**

At times, I think it should embarrass me that the lyric in all of modern music that has touched me the most deeply and for the longest time, that has been one that I have hung onto as a vine of clarification, that has given what is a profoundly muddled clod of an internal life make some small sense is 'a loaded gun won't set you free, so you say'.

At times, I think it should embarrass me that I continue to listen to the song that shelters this line, 'New Dawn Fades.' (God, what a title!) My personal fandom that has lasted from age seventeen until now, age thirty-seven. Without fail, those lyrics cause me to weep quietly, just a little. It is happening now as I listen to it while writing this.

At times, I think it should embarrass me because I had the honour to play two large festival shows covering all of *Unknown Pleasures* from beginning to end. Tears streamed down my face in public while I was singing those words. Thankfully, I sweat so much while at shows no one could tell the difference.

I should be embarrassed by these things, but I am so intensely not alone in feeling this way, that all uncertainty is swept aside by collective emotion. I cannot but embrace my teen feelings, reactions as uncontrollable facts of being a particular type of person. Being a particular type of person who found what he needed.

Knowing that there is a line, a song, a band that allows the question of suicide to be so bold, so revealed, so confrontational, is such an incredible comfort and release. To feel as if life is so pointless or hurts so much to continue to participate in it is a source of incredible guilt. However, this guilt only compounds and reinforces the ridiculously ridiculous horrible pain and fear that causes one to latch onto suicide as an option in the first place.

To hear someone you admire as a musician sing, essentially, 'you think that having had enough of life is wrong, but it is you who are wrong,' is an unfettered and true relief. The oppressiveness of a hidden shame dims slightly. It loosens the shackles just enough to get through one more day of staying and seeing what else unfolds.

Suicide, in most cases, is the most selfish human act. In the song, Ian Curtis screams 'ME! It was ME! Waiting for ME again!'

Selfishness is as embarrassing as suicidal ideation but it is only made that much worse by not articulating it. *New Dawn Fades* takes this bold leap into what cannot be said and probably what should not be said to anyone except for the specific people whose stars are so unaligned as to need to hear this again and again to keep their place in this dimension.

In its seething musical bed of the most starkly moving, perfectly wrought and artfully unadorned guitar, bass and drums, no one else has ever expressed to me the acceptance of a lack of meaning better. No one has as directly. No one has as belicvably. No one has as essentially.

Thank you, Ian. I am sorry there was no one to sing this song to you.

Science is the ultimate pornography, analytic activity whose main aim is to isolate objects or events from their contexts in time and space. This obsession with the specific activity of quantified functions is what science shares with pornography.

**JG BALLARD,** *THE ATROCITY EXHIBITION*

You'll see the horrors of a faraway place,
Meet the architects of law face to face.
See mass murder on a scale you've never seen,
And all the ones who try hard to succeed.

**IAN CURTIS,** *THE ATROCITY EXHIBITION*

# THE PORNOGRAPHY OF SCIENCE

## Curtis, Ballard and Burroughs

**JASON WHITTAKER**

eleased two months after the suicide of Ian Curtis, Joy Division's bleak, austerely beautiful second album, *Closer*, opens with an evocative, deep bass line and rhythmic drums that simulate the sound of rapid gunfire. The album was immediately recognized as a much darker work than the group's first release, a masterpiece whose glories were all too starkly illuminated by the tragic death of the lead singer. That first track, however, also drew attention to Curtis' taste for what the music critic, Jon Savage, called 'offbeat literature'. Reading widely, Curtis devoured writers such as Dostoevsky and Kafka, and in a 1980 interview with Alan Hempsall, he named William Burroughs' *Naked Lunch* and *The Wild Boys* as his favourite novels. *Atrocity Exhibition*, the first track on *Closer*, took its inspiration from much nearer to home, however, drawing not from the Beats in San

Francisco and New York but the suburbs of Shepperton where the science fiction writer, JG Ballard, concocted surreal fables of the contemporary world. As part of the British SF new wave, Ballard's visions of 1970s urban landscapes clearly resonated with Curtis' experiences living in postwar Macclesfield.

Christopher Partridge has coined the term 'occulture' to refer to hidden cultures and subcultures in the west which, in the work of a number of writers, artists and musicians such as Burroughs, Robert Anton Wilson, Coil and Psychic TV tended to be heavily influenced by the occult in some shape or form. This link between art and spirituality was a predominant theme of his two-volume work, *Re-Enchantment of the West* (2004–05), but more helpful here is Partridge's recent emphasis on the 'ordinariness' of occulture, the ways in which contemporary society has been much more amenable to once esoteric

ideas. This sense of an alternative culture hidden in plain sight is one of immense appeal to a wide range of movements in the twentieth century, whether the Beats in the USA, the Situationist International in France and elsewhere in Europe and, of course, punk and its offshoots in Britain. Genesis P-Orridge, frontman for Throbbing Gristle and Psychic TV, began to crystallize his own notions of what occulture could mean in the 1990s through his work with Thee Temple ov Psychick Youth — particularly with regard to sexual and magical practices drawing on the work of the artists Austin Osman Spare and Brion Gysin, as well as the cut-up practices of Burroughs and thelemic pseudophilosophy of Aleister Crowley — but much of its origins lay in P-Orridge's experiences as part of the post-punk scene in 1970s Britain.

Before becoming involved with the musical new wave that followed the spectacular demise of punk, P-Orridge had, with Cosey Fanni Tutti, been part of an art collective, Coum Transmissions, specializing in transgressive performances and exhibitions, most notoriously the show *Prostitution* at the ICA in 1976. This exhibition led the conservative MP, Sir Nicholas Fairbairn, to question why the government of the day was supporting such events (including photos of Tutti's work as a pornographic model as well as her used tampons hung as visceral found objects), denouncing P-Orridge and Tutti as 'wreckers of civilization.' Coum Transmissions, which included influences such as Fluxus and the ritual debasements of the Viennese Actionists, certainly attracted a degree of attention within the art community, but as art, that is a specific set of organized activities that took place within a structure of well-regulated spaces and events, it was too easy to be recuperated. In the end, Coum's work could be assimilated back into an elite culture which could tolerate almost any amount of depravity among the avant garde as long as mass culture was kept safely inoculated from harm — after all, that was where the real danger lay. As such, and greatly influenced by punk, P-Orridge decided to take his shock tactics to a wider public, forming the band Throbbing Gristle with Tutti, Peter Christopherson and Chris Carter, and setting up the label Industrial Records in the same year as the *Prostitution* exhibition. As part of a wider generation that, since 1968 had expressed its increasing disaffection with the postwar status quo, Throbbing Gristle belonged to the scene that brought P-Orridge into contact with Joy Division. In a 2003 interview, P-Orridge remarked that both he and Curtis were born 'in the same post-industrial manufacturing slave vortex of Manchester, England,' and indeed claimed to have spoken to Curtis just before the singer's suicide, experience which fed into 'I. C. Water' on the album *Towards Thee Infinite Beat* (1990). Whatever the truth of P-Orridge's conversation, his observations that Joy Division's music caught the psychogeography of Manchester perfectly rings true as an example of the ordinary occulture of Curtis' lyrics.

While the bleak music of both Joy Division and Throbbing Gristle could easily share an adulation for alienation that leads to what Jennifer Otter Bickerdike calls 'Rock N Roll Romanticism', their fascination with a particular type of offbeat literature typified by Burroughs

and Ballard lends an anti-Romantic tone to their output. P-Orridge's notion of 'deprogramming' drew explicitly on the work of Burroughs, who in novels such as *Naked Lunch* (1959), *Nova Express* (1964) and *The Ticket that Exploded* (1962) offered a series of highly experimental assaults on human psychology that denied that very sense of the stable self — the outlaw against the world — on which Romanticism ultimately depends. If the individual is to be sure of himself (or very occasionally herself) in the face of public indifference or scorn, then the very core of that self needs to be absolutely sure that it can, like the Byronic antihero, rise above all such adversity through its moral superiority. For the romantic, alienation provides the emotional stimulus to shore up the self, defining it with greater clarity. In Burroughs, by contrast, alienation infects us all through the virus of language,

an amoral act that makes us all junkies, all as bizarre as the Mugwumps of his *Naked Lunch* or the once-human Reptiles that are addicted to their sticky, seminal fluids.

P-Orridge's fascination with Burroughs, who saw the cut-up and obscenity as a means of refusing control, was clearly shared by Curtis. Yet the more immediate effect on Curtis' lyrics came not from the American but a then obscure British writer, JG Ballard. Ballard's novel, written as a series of disjointed routines in the late 1960s and published as *The Atrocity Exhibtion* in 1970, provided a title to the opening track of *Closer*, although it is not entirely clear how much of the novel Curtis had read when he came to write down his own words a decade later. Indeed, it is unclear how anyone can exactly read Ballard's novel through its series of cool, disjointed scenes. In his preface to *The Atrocity Exhibition*, Burroughs observed that the book 'stirs sexual depths untouched by the hardest-core illustrated porn', a series of dispassionate dream sequences that owe as much to the automatic writings of the Surrealists and the technical jargon of scientific papers as Burroughs' own cut-ups.

As part of the 1960s and seventies science fiction new wave, Ballard had produced a series of disquieting novels that moved away from clearly futuristic scenarios to the immediate environment of contemporary Europe and America. Rather like the affectless man who fell to earth as David Bowie in Nicholas Roeg's 1976 movie, Ballard's protagonists in books such as *Crash* (1973), *Concrete Island* (1974), and *High-Rise* (1975) explored the psychopathology of everyday life in vivid and disturbing

ways. Ballard categorized these novels as science fiction, drawing opprobrium from those fans of the genre that missed all the accoutrements of space opera, time travel and superhuman capabilities, creating instead a contemporary dystopian vision of technology which turned the cold logic of a dispassionate, scientific gaze upon the both all-too-familiar and utterly unrecognizable landscape of 1970s London. It is this perverse psychogeography, expressed in psychopathic and surrealist interpretations of motorway flyovers and neo-Brutalist office blocks, that Curtis obviously responded to when creating what Paul Morley called the singer's own science fiction interpretation of Manchester as an alien landscape.

Throughout the 1970s, Ballard's dispassionate gaze was directed at urban transformations which most people failed to see for looking. In *Concrete Island*, for example, the protagonist, Robert Maitland, crashes his car at an intersection at the M4 motorway and, unable to escape in a Kafkaesque parody of uncaring incarceration, discovers the underbelly of a society that is even more frightening; the book is stripped of the Max Ernst beauty that informed Ballard's earlier disaster novels such as *The Drowned World* (1962) and *The Crystal World* (1966). The anxiety that Ballard evokes through this mundane occulture owes nothing to sensations of religion or mysticism, for the supernatural has been replaced not by the natural, in any sense of a traditional dichotomy between heaven and earth, but rather the utterly artificial, the man-made world of the late twentieth century. Rather than vegetative

beauty of creation behind which lies the eternal glory of the divine, everything in Ballard's novels from this period is reduced to a surface of steel, glass and concrete: everything is exposed to the gaze in what the author referred to in interviews as the 'pornography of science', forcing us to look on our daily existence with a terrifying sense that nothing is known for all that it is so familiar. This scientific and technological pornography renders flesh, sinew, bone and mucous membranes all of a piece with the leather and steel of a car's interior, the brushed concrete and synthetic fabric seats of an airport lounge, or the troubling angle between two walls. In many respects, Ballard's work from this period is subject to the typical critique of more conventional pornography as a dehumanizing experience, one that is especially misogynistic as it tends to focus on the dissection and dislocation of the female body, as in the following extract from *The Atrocity Exhibition*:

*The Sex Kit. 'In a sense,' Dr Nathan explained to Koester, 'one may regard this as a kit, which Talbert has devised, entitled "Karen Novotny" — it might even be feasible to market it commercially. It contains the following items: (1) Pad of pubic hair, (2) a latex face mask, (3) six detachable mouths, (4) a set of smiles, (5) a pair of breasts, left nipple marked by a small ulcer, (6) a set of non-chafe orifices, (7) photo cut-outs of a number of narrative situations — the girl doing this and that, (8) a list of dialogue samples, of inane chatter, (9) a set of noise levels, (10) descriptive techniques for a variety of sex acts, (11) a torn anal detrusor muscle, (12) a glossary of idioms and catch*

J G BALLARD
AUTHOR OF
EMPIRE OF THE SUN

THE ATROCITY
EXHIBITION

'ONE OF THE MOST
BRILLIANT, UNNERVING FICTION WRITERS'
THE TIMES

*phrases, (13) an analysis of odour traces (from various vents), mostly purines, etc., (14) a chart of body temperatures (axillary, buccal, rectal), (15) slides of vaginal smears, chiefly Ortho-Gynol jelly, (16) a set of blood pressures, systolic 120, diastolic seventy rising to 200/150 at onset of orgasm...' Deferring to Koester, Dr Nathan put down the typescript. 'There are one or two other bits and pieces, but together the inventory is an adequate picture of a woman, who could easily be reconstituted from it. In fact, such a list may well be more stimulating than the real thing. Now that sex is becoming more and more a conceptual act, an intellectualization divorced from affect and physiology alike, one has to bear in mind the positive merits of the sexual perversions. Talbert's library of cheap photo-pornography is in fact a vital literature, a kindling of the few taste buds left in the jaded palates of our so-called sexuality.'*

This certainly demonstrates the novel's apparent misogyny (as much in the reference to a woman's 'inane chatter' as anything else). It is important, however, to note that this is the doctor's assessment of Karen Novotny more than the patient's. Throughout *The Atrocity Exhibition*, Talbert (whose name changes from chapter to chapter as a sign of his schizoid existence) repeatedly shores up the fragments of himself against the onslaught of an increasingly inhuman mass media landscape, as well as the recollections of the atomic destruction of Nagasaki and Hiroshima. For him there is, as for the narrator of *The Waste Land*, at least some realization of what is being lost in this quantification and isolation of human experience. For science, however, sex has always been a 'conceptual act', and the technical language used to describe Karen's body ('anal detrusor muscle,' 'axillary, buccal, rectal,' 'a set of blood pressures, systolic... diastolic...') is reminiscent of Roland Barthes' contrast of the striptease as only truly erotic when it teases, hides more than it reveals. The pornographic gaze, like the scientific one, wishes everything to be exposed at once, which is the end of desire.

This detachment is frequently encountered in the numb, eerie sound of Joy Division. For example, when Curtis describes the effects of a grand mal seizure in *She's Lost Control*, the deep, almost emotionless voice offers a similar effect to the doctors witnessing Talbert's breakdown in *The Atrocity Exhibition*. However as David Church points out in a paper on Curtis, rock and disability, the singer was drawing on his own very painful experiences as a disablement

officer even before his own epilepsy was discovered. Likewise, while the analytical gaze underlines Ballard's cool prose, he presents his characters as subject to horror and pity as well as clinical objects of study: the sociopaths of his 1970s novels are his own Frankensteinian creations, human beings that should evoke pathos as well as fear in the reader. What is more, the references to Nagasaki and Hiroshima are reminders of what terrors technology holds, that we live after the time of atomic warfare, something that had affected Ballard personally as it was the absolute destruction of those two cities that brought to an end his own experiences of atrocities in a Japanese-run concentration camp.

The pornographic gaze, then, as the companion of the scientific gaze, may seek to impose control through such detachment, revealing sex and horror explicitly as a series of surfaces without hidden depths, as infinitely malleable as the perfect sex organ or medical apparatus. There are no secrets here. And yet what Curtis catches in his own *Atrocity Exhibition*, like Ballard, is the pathos that the pornography of science fails to uncover in its strangely blind vision. As Church observes, Curtis often referred to himself as an atrocity exhibition, 'speaking like a sideshow barker inviting audiences to the spectacle,' demonstrating the tensions between a freakish rock star and incidences of his own disability. All was, apparently, on display to the disembodied view of an audience that could combine psychopathology with the erotic excitement of a rock show to satisfy its jaded palates of its so-called sexuality. One can almost imagine the parodic 'indie rock star kit': 1) dress shirt and suit pants; 2) series of myoclonic spasms resulting in irregular motion of upper limbs; 3) intense expression with occasional rictus convulsions; 4) baritone voice; 5) expectant audience waiting for potential tonic-clonic seizure. Curtis, of course, made the point much more evocatively in *She's Lost Control*:

*And she screamed out kicking on her side / And said 'I've lost control again' / And seized up on the floor I thought she'd die / She said 'I've lost control'*

Because Curtis never revealed the extent of his own disability, there were occasional outbreaks of violence at gigs where the show was cancelled because of a seizure. As Church observes, Curtis' body occupied an all too terrible space as atrocious spectacle. In such a space, it is all too easy for the pornography of science to dominate, coolly refusing any empathy with the object of the gaze in order to create an easily duplicated kit that can be distributed commercially. An understanding of this atrocity exhibition, the inability to connect to that other, is what Curtis shares with Ballard and, indeed, Burroughs, that in our search for something to stimulate us we are content to watch any act, however despicable — and that this is a condition of the modern, technological world. In contrast to the singer of *She's Lost Control*, *Atrocity Exhibition* and, perhaps most sadly, *Love Will Tear Us Apart*, an audience in search of spectacle will always isolate and quantify what it sees, unable to connect with those living beings who are the objects of its entertainment.

# BOOKSHELF

## Curtis in Manchster bookshops

**SAVOY CO-FOUNDER MICHAEL BUTTERWORTH
(AS TOLD TO DAVID KEREKES)**

The recollections we have of Ian Curtis visiting our [Manchester] shops have been documented by Jon Savage in a *Guardian* article a couple of years ago. BUT, we've now discovered it is inaccurate. Stephen Morris visited [our shop] House on the Borderland with another friend, not Ian. House on the Borderland was circa 1972, and Curtis didn't come on the scene until much later. But he *did* come into our Bookchain on Peter Street, in keeping with most of the Factory mafia and the Manchester music scene of the day. They were attracted to the cult books/comics and underground/bootleg records before the big chains gradually took these markets away from us. Our shop manager of the time John Mottershead remembers Ian well. John recalls that Ian would both buy and sell — he bought when he was flush and sold when he was broke.

I do not want a plain box, I want a sarcophagus
With tigery stripes, and a face on it
Round as the moon, to stare up.
I want to be looking at them when they come
Picking among the dumb minerals, the roots.

**PLATH FROM *LAST WORDS* (1990)**

Photos in this chapter: Gail Crowther

# THE UNQUIET GRAVES OF IAN CURTIS AND SYLVIA PLATH

### GAIL CROWTHER

The narrator of Plath's poem, *Last Words*, wants a spectacular resting place. A tigery-striped sarcophagus, and a painted face as round as the moon to be looking at future visitors when they arrive. We tend to think of graves as 'resting places': places of repose and quietude where the departed settle into their final, eternal sleep and the names engraved on the stones green and fade with age. Yet the graves of Ian Curtis and Sylvia Plath are far from this oasis of tranquillity. They are vibrant, busy places full of trinkets, mementoes, pictures, flowers, and candles. They are unquiet, contested places of rest. In July 2008, the original gravestone of Ian Curtis in Macclesfield Cemetery was prised up, removed and never returned. Within a month, his wife Deborah Curtis replaced the missing headstone with a new memorial. In the 1980s, the gravestone of Sylvia Plath in Heptonstall, West Yorkshire, was repeatedly vandalized until it was removed altogether, leaving the grave unmarked for many months.

These two figures that haunt our cultural landscape have much in common. Both were talented, beautiful artists who died young. Both committed suicide. Both have loyal and attached fan bases that visit their graves regularly and repeatedly year after year. Both have unassuming, yet busy resting places. According to Macclesfield Council, over 1,000 people visit Curtis' grave each year from around the world. This number would certainly be matched, perhaps even surpassed, for Plath, with claims that she has several visitors every day of the year.

What gets performed when fans make a 'secular pilgrimage' to the graves of Curtis and Plath? What gets taken, what gets left behind, and what do fans gain from such a pilgrimage? Remembrance and loss,

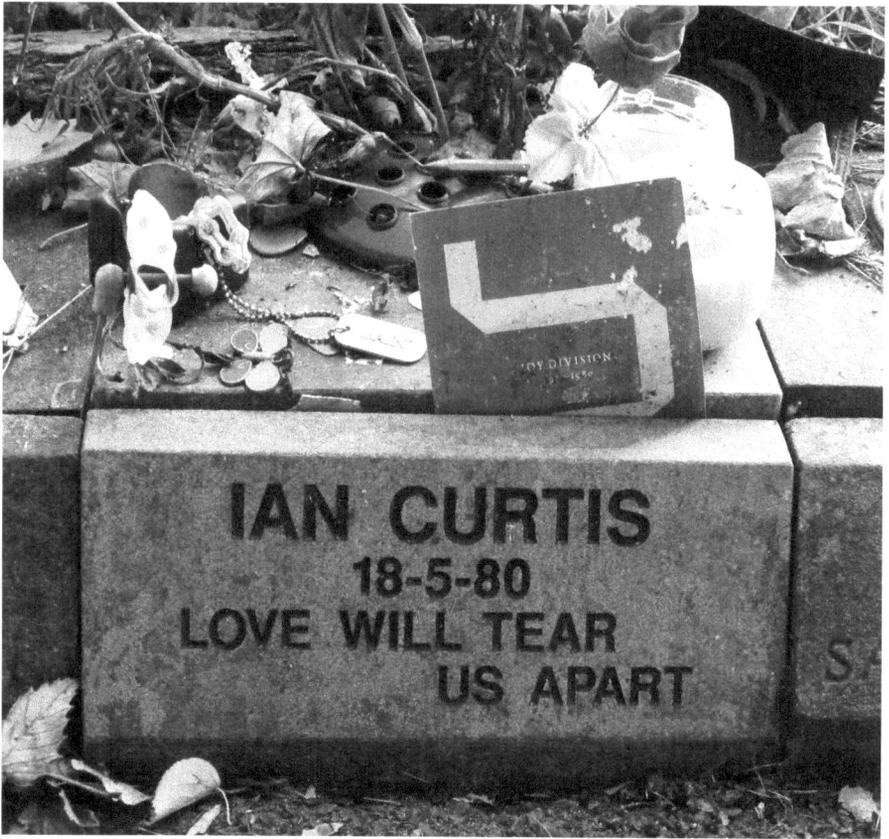

daydreams and fantasies are explored in relation to the fans' attachment as we listen to some of their stories. Absence and presence are equally explored; that overwhelming presence which makes itself felt from an absent body. A public site of private mourning also creates a paradox, for both of these graves now have a sense of community about them. They are a meeting point at which individual desires, emotions and feelings can be shared collectively. What *might* be the motivation behind such a secular pilgrimage and why *do* fans leave candles, flowers, trinkets, pens and statues? Why are these graves so unquiet?

The importance of place is not a new phenomenon. It can be traced back hundreds, even thousands, of years. Religious pilgrimage to places of significance has both an individual and a social dimension. One of the best-known religious pilgrimages described in literature is Chaucer's *Canterbury Tales*, an account which captures the excitement of a journey to venerate a saint ('Thanne longen folk to goon on pilgrimages').

A traditional pilgrimage can be very much about a pilgrim leaving their usual world and seeking something that will enrich them outside of 'normal' life. The sites visited often have some form of tragedy, disruption or images of death associated with them. Chris Rojek discusses this in relation to what he calls 'black spots', areas of sudden

and violent death or the commercial development of grave sites. For some, visiting death sites and graves can be seen as ghoulish, but that doesn't mean it isn't an attempt to somehow make sense of the meaninglessness of death or to simply stand awhile and remember. As such, the key elements of pilgrimage may involve journeying beyond the parameters of 'normal' life and searching for something new in a different world.

While the reason for making a pilgrimage may be precipitated by anything from veneration to curiosity, the general idea is that the quest will somehow enhance the pilgrim's own sense of well-being and, in some cases, affirm a sense of cultural identity. This certainly seems to be the case with many pilgrims who visit the graves of Curtis and Plath. Jennifer Otter Bickerdike, the editor of this collection of essays, recalls her own experience and reasons for a secular pilgrimage to Macclesfield Cemetery and other sites roundabout. In fact, she refers to this as a 'sonic pilgrimage' based on the music that she listened to while she was growing up:

*From as far back as four years old, I would say I was an anglophile. I would 'borrow' my parents' original issue Beatles and Stones albums, and play them on my fat-needled Fisher-Price record player. By the time I took my first trip to England from my native California, I had an unexplainable need to see the places that had inspired my idols, the people who had created not only the soundscape but provided my cultural cues for identity  Morrissey, the Brontë sisters, Sylvia Plath, the gents of Joy Division and New Order. I went on many of these 'sonic pilgrimages' each time I visited*

*the UK, taking loads of pictures.*

Here Bickerdike acknowledges the role that people like Curtis and Plath played in providing what she terms 'cultural cues for identity'. That is, the music and words of certain singers and poets played a direct part in her identity formation, but furthermore added to a sense of her own well-being too:

*The music of Joy Division paired with the mythos of Curtis provides comfort and companionship, especially as many of these emotions may not be socially acceptable to dwell upon or express. Here is someone else who truly (as illustrated by his death) felt these things — you are not alone. For me, a few of their songs I find profoundly affecting, and they have been the only thing to pull me through some difficult times.*

In this sense, we can see a pilgrimage to Curtis' grave having a multilayered purpose: veneration of a cultural figure who has offered comfort and companionship through difficult times; ways of viewing the world and expressing emotions that helped the listener negotiate and navigate through the difficult years of growing up; a desire to see places that inspired the lyrics of Curtis, and a wish to pay homage and thanks to Curtis at his grave. The type of trinkets and mementoes that are left reflect these emotions. Candles are lit for remembrance, flowers and pictures, personal messages of thanks, coins, stones, buttons, bracelets with Ian's name, soggy cigarettes. The grave is loaded with meaning and often these trinkets spill over to the graves on either side. The site is a meeting place, a bringing together of people from all over the world, partly to commemorate Curtis, but also, perhaps

we might even say inadvertently, creating a community of mourning and devotion.

For another fan, Sam, visiting the grave of Ian Curtis was not only about paying his respects, but it also had something to do with a sense of proximity to the person he so revered:

*I never got to see Joy Division or Ian Curtis play, I was a little bit too young when they were around, so by the time I was deeply into the lyrics of Curtis, he was already dead. I travelled to Macclesfield because I wanted to pay my respects at his grave, but it also felt like that would be the closest I would ever get to him. I know that sounds stupid, especially since it is his ashes buried there, but that is all that is left of him now and so in a weird sort of way it is the closest I'll ever get to who he was. I left just one flower. I wanted to say thank you and goodbye, except it wasn't really goodbye as I feel like he is always with me every time I listen to the songs.*

Here we see one of the primary purposes of a grave come into play — that is as a site of remembrance and mourning. Standing awhile at the graveside of a much loved, lost figure allows space to pay homage and paradoxically to both say goodbye and bring back the one who has gone. Mementoes are about remembrance, but of course remembering in itself can also be about accepting loss. Yet through the act of remembrance, it is possible to bring someone 'back,' however unsatisfactorily. For Sam, although he understands in many ways Curtis is absent, he still feels his presence every time he listens to Joy Division, and in this sense, Curtis is reanimated for him and plays an active role in his daily life.

So, on one level, visiting a grave may be about an element of personal fulfilment (the experience of venerating, for example, a much loved figure), whereas on another social level the experience of a pilgrimage can form a temporary community, a *communitas*, bound together in a common purpose.

This notion of *communitas* can be found in the work of Peter Jan Margry, who explored pilgrimages made to Jim Morrison's grave in Père Lachaise cemetery in Paris. So hallowed is the area around Morrison's grave that it has even been given its own name — *espace Morrison*. Fans gather to transform the grave into a socio-cultural space, drinking alcohol, taking drugs, removing their clothes, having sex, reading poems and playing music. We can draw parallels here with the grave of Ian Curtis where items such as condoms and even a vibrator have been left! Such was the activity in Paris that Morrison's grave became a contested site and on April 15, 2004, was annexed off by graveyard officials. Extra security checks were carried out, spikes placed around the cemetery fences in an attempt to keep out and break up the community that had formed. Now, while fans cannot access or touch the grave, they still collect around the barrier and leave gifts for Morrison. Again, as with Curtis and Plath, we see a tension between a private burial place becoming a public place of mourning and remembrance and the conflict that this can bring about.

This type of pilgrimage involves a certain amount of daydreaming by the pilgrim. Standing in a place, whether that is a grave or a death site, and imagining the person you are visiting involves the imposition of fantasy on the part of the pilgrim. But more than this, in many ways, as we have already discussed, it

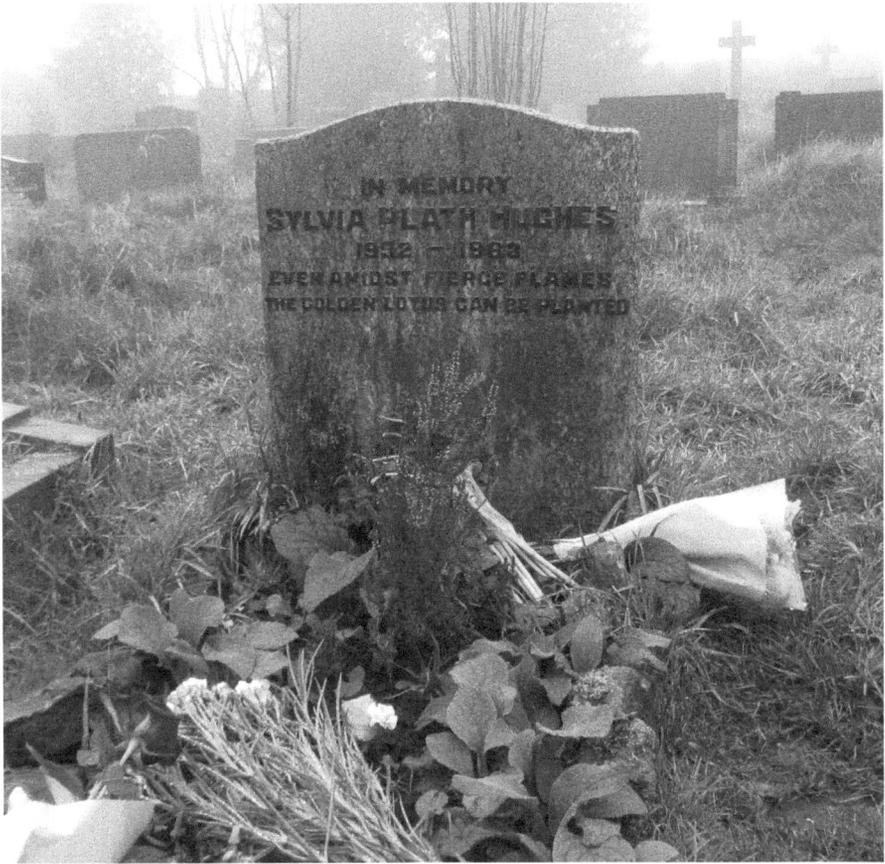

involves the *resurrection* of the lost, dead one, as if a thought can make them return. Thus grave sites become paradoxes. They are primarily about loss, but they are also about return. They are private places of burial that can become public sites of mourning. They are about an individual person, but as the graves of Curtis and Plath show, they can become about a collective, a *communitas*. They are referred to as resting places, yet they are completely unquiet. Furthermore, they are about the absence of a body which appears to curiously be suddenly *more* present by its very absence.

This revivification of the dead is evident in many accounts of readers who have visited the grave of Plath. One pilgrim, Peter, recalls:

*The bus follows a river and a windy road through hills and towns for eight miles. The fields are way off and lush green, with brown brick walls marking the territory. Dark clouds came and went, quick and steady. As we approached Hebden Bridge I saw, atop a massive hill, a huge old church tower. I asked the lady behind me 'Is that Heptonstall?' (I had several dreams that summer about being on the bus, in bright, bright sun light travelling through land just like that of what we were seeing. And in the dream, atop a huge hill sat a church just like the one we could see. I got goose bumps on my neck and arms.) At the graveside from*

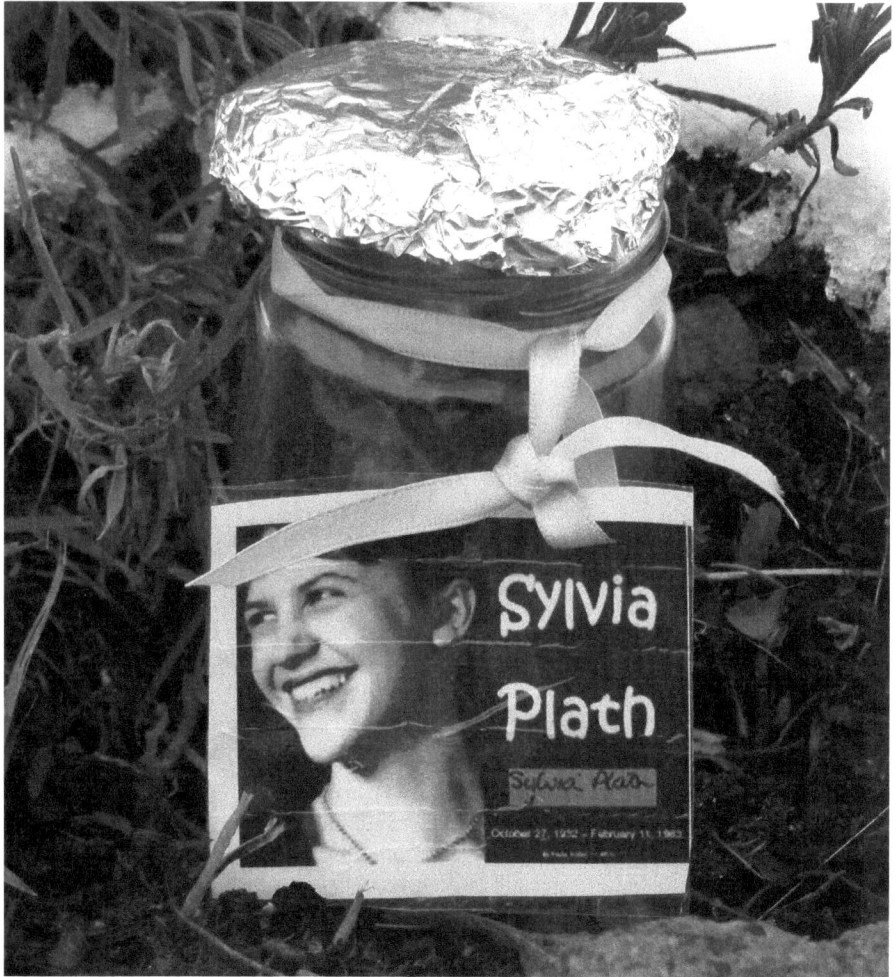

*memory I recited 'Lady Lazarus'. There were two black cats a few rows to the west. Birds flew overhead out from the bell tower, and more birds flew into the flock. The wind picked up almost instantly and I began to think that by reciting the poem that Sylvia Plath was rising from her grave. The eerie elements in place I said again 'Out of the ash / I rise with my red hair / And I eat men like air.' I asked into the wind, 'Are you coming?' and it started to rain.*

In this account, Peter appears to be actively trying to raise Plath from the dead. With the bell tower and the church and the birds and wind, it all depicts quite a gothic, creepy scene. His daydreaming comes to the fore as he feels reading a poem might actually bring Plath back and he even speaks directly to Plath: 'Are you coming?' Peter is the captivated reader whose recitation of a poem at the grave side of Plath has a ritualistic, invocatory element to it: a wish to call up the lost object of his desire like a medium during a séance. There is a wish to connect, to create a meeting point by intoning Plath's own written words.

Like Curtis, Plath's grave is often littered

with a variety of trinkets and offerings. Sometimes these relate directly to her work (such as red tulips); sometimes they refer to her art (a container full of pens and pencils), and sometimes they seem simply to be personal messages from pilgrims (cards saying thank you or quoting special lines of poetry).

For fan Ellie it was not simply about what she left at Plath's grave, but also what she took away. Her first visit, made years ago in 1989, coincided with the grave of Plath being vandalized and the stone being removed. Ellie however struck lucky:

*I was not sure I would find the grave since the stone had been repeatedly vandalized with the name 'Hughes' prised off by activists upset that Hughes' name was on the grave when at the time of her death Plath and Hughes were separated. The grass in the graveyard annexed to the gothic ruin and newer church was wet under foot. I walked the rows starting at the bottom and moving upwards. My heart rate accelerated. Surprisingly, I came across Sylvia's grave quite quickly with the headstone replaced and ironically the word HUGHES standing out in shiny, black, new letters. I was disappointed that the grave was in a row with others, feeling it should be set apart like Marx's grave in Highgate cemetery. It should be making a statement. She was not like other people... I was both disappointed and amazed. It was the closest I would ever get. I was being grisly. I tell the person I am with as I pick up soil, 'there might be bits of Sylvia in this' and I put it in my pocket.*

There are some similarities between Ellie and Peter's stories. The gothic old church plays a part in both narratives, as does the rain and the idea of being 'close' to Plath. Both express a yearning, mourning for the one they have lost. Both experience the physical impact of place; for Peter it was goosebumps, for Ellie an accelerated heart rate. Both try to invoke her presence. Peter asks Plath, 'are you coming?' Ellie, in a slightly more grisly ritual, sifts through the soil for physical traces of Plath: the body, the tangible, still haunting after all these years.

If places are not fixed and unchanging but depend upon what gets bodily performed in them by visiting guests, then they must also surely be culturally produced. Ground, soil, a grave, can hold more meaning for one person than anywhere else on earth. The fact that Ellie was initially disappointed with Plath's grave, that somehow it wasn't 'grander', shows the values we confer to physical sites; further, the emotional attachments we create become part of who we are, part of the stories we tell and the places we go. The space we visit at the graves of Curtis and Plath is both public and private. It may be meaningless to the next person.

Yet visiting a burial site does raise the seemingly obvious question: In what sense is this person gone? Whether they *are* actually 'gone' is questionable when often dead people become more visible, present and endurable with their physical absence.

Certainly at best we can say that Curtis and Plath left a legacy of words which ensures at the very least a textual and sonic immortality. For this very reason alone, their graves are likely to remain messily unquiet. But this will also ensure their continuing presence in our cultural lives. Perhaps the title of a publication of Curtis' lyrics and notebooks says it all:

*So This is Permanence.*

# THE LEGEND OF CORNELIA F

## JENNIFER OTTER BICKERDIKE

Several kerbs down from Ian, there is a simple engraved stone. Marked with just 'Cornelia F–1993 TAKE MY HAND I'LL SHOW YOU', the memorial stands testament to the power of song lyrics. Taken from Joy Division's *Atrocity Exhibition*, the full line reads 'Can't replace or relate, can't release or repair / Take my hand and I'll show you what was and will be.' Cornelia F's proximity to Curtis and the use of his partial lyric led me to inquire: Who was Cornelia F and how did she end up by Ian?

Cornelia F was a massive Joy Division fan from Germany. She asked to be cremated, similarly to Curtis, and have her ashes interred as close to the singer as possible. Like Ian, Cornelia died by her own hand. She now rests less than a foot away from the icon. In some respects, it seems the ultimate in fan devotion, an almost martyr-like taking away of life in some sort of dark solidarity — as if Cornelia F alone truly understood

the darkness, the depth and despair in Curtis' writing. Instead of finding hope and solace in Joy Division's community of words, Cornelia drowned in the meaning, suffocated by the very same lines which have brought others relief and release. Now she lies — probably closer to Curtis in death than she may have ever been in life — as if guarding him against the wayward, keeping him for herself — looking on at the parade of fans and pilgrims who come to pay tribute to the singer. Yet in this death, she is similarly still waiting for the guide to take her by the hand — as her stone is still outside the parameter of the glance, the view and the worship. She remains an onlooker, one of the many just participating in the adulation of Curtis. The bareness of her stone, even the chosen words — did Cornelia F relate to Curtis, relate so much as to want to spend eternity next to him? Even this last message, as if gasped from the grave itself, offers but a glimpse of the paradox of fandom: as to be a fan

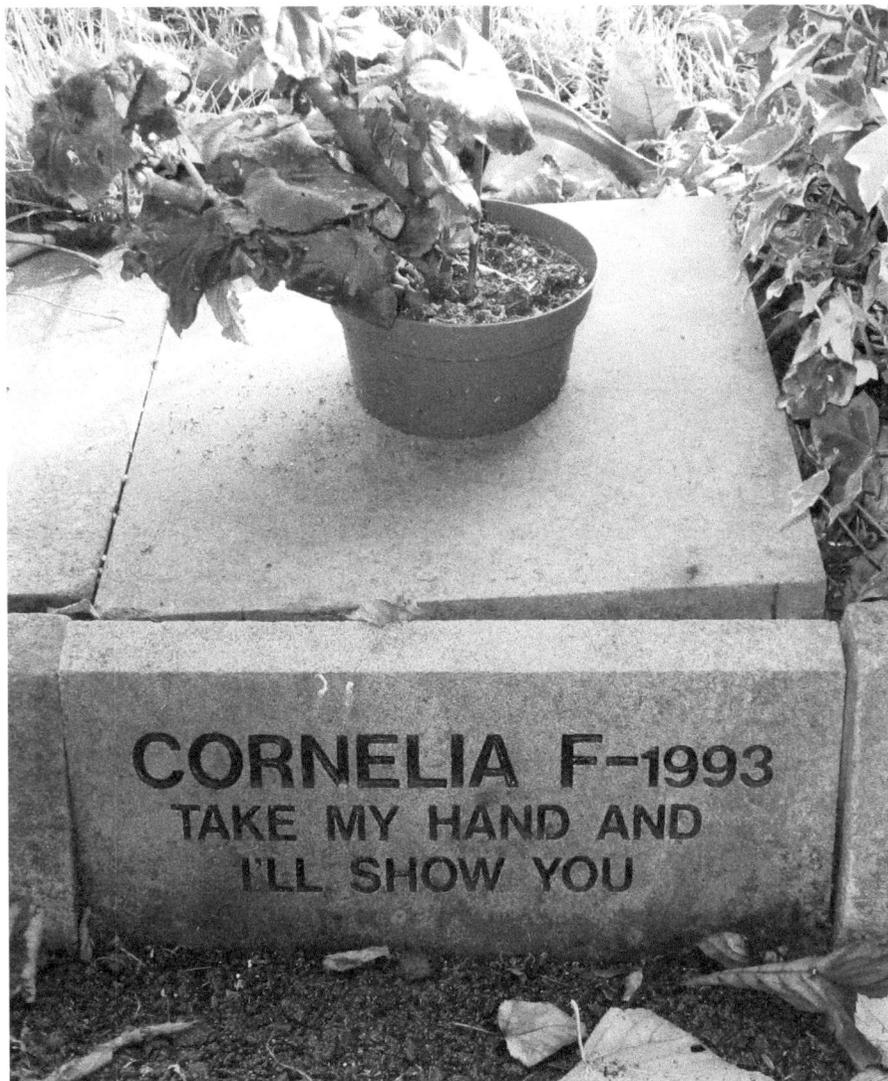

CORNELIA F-1993
TAKE MY HAND AND
I'LL SHOW YOU

is to want, to feel the embodiment, of some part of a song, a message, a singer, a movement.

Cornelia F's story is murky at best, passed on from my friend Robert who has been at the crematorium since Curtis became a resident. Cornelia F's arrival was a part of the everyday routine at the crematorium; relating her particular circumstances would test the memory of anyone. The truth of who she was, how she ended up in Macclesfield Cemetery, a German fan, far away from everyone one would assume was familiar, will probably always remain unknown; Cornelia F, who she may have been, will fade, be forgotten, a legend in herself. She only now is a tiny footnote because Robert kindly talks to all the curious and obsessive Joy Division fans who come to the cemetery. I will remember — this one is to you, Cornelia, F — for what will be.

Photos in this chapter: Macclesfield/Macclesfield cemetery, September 2009–December 2010.

# DARK TOURISM

## JENNIFER OTTER BICKERDIKE
## (AS TOLD TO DAVID KEREKES)

As part of the practical side of my PhD, I went to the grave of Ian Curtis, late singer of Joy Division, on the same day of every month for a year. The main purpose was to document what people left, what people took and how the grave as a space changed and evolved over time — much like the myth of Curtis and Joy Division.

Joy Division are the 'what if?' band, which is why I believe so many people are so infatuated with them. New Order went on to amazing, and much greater heights; I often get in internal conflicts with myself, as I *love* New Order, probably more than Joy Division; but there is something about the urgency, the outcome and the legacy of what could have been Ian Curtis' life that is so compelling, it just hits you at the gut level in a way that no other band of that time, and I would argue, probably not until Nirvana and Cobain's death, has done again. More than any other band that comes to mind is that Joy Division's worldwide fame occurred *after* Ian died.

That has all of the trappings of the classic Byronic hero, which is again irresistible. Musically, they took punk and moved it forward in a way that uniquely reflected that moment in time and space. But at the same time, the themes of Ian's lyrics, the bass lines of Hooky, the overall feel of many of the songs, are timeless in their perfection. They don't sound dated at all. Living in the twenty-first century has become almost synonymous with disposable, instant, and a fan-for-a-single culture. The fact that Joy Division still attract new fans, still sound amazing, still touch and change people's lives speaks of the importance of the dying art of quality, and *meaning* behind music and style. Tony Wilson once said about Joy Division something along the lines of *they had to perform* — it was not a choice. It was about expressing those ideas at that moment — not having five seconds of fame on some shit reality TV show, or getting hundreds of followers on social media. *It meant something* — and we are living in a vacuum of meaning at the moment.

The overriding image of my time going to Ian's grave can really be summed up in

two visits: one, the thirtieth anniversary of his death, and the other the month following the anniversary. There were several hundred people who came on May 18 to pay homage to Ian. They left teddy bears, Man City flags, flowers, cards, guitar pics, pictures, train tickets piled on his grave. It was a beautiful, sunny, warm day — completely contrary to the grim and dreary North we are accustomed to hearing about. However, the next visit was completely opposite. All of the paper goods and greenery had died, decomposed to some degree and looked like a refuse pile. The bear and flag were coated in mud and looked like they had been run over 200 times by a truck. It was disintegration, death and decay. No one was around and it was wet, windy and cold, lonely and abandoned. It was overall symbolic of the split that we hear about so much in Curtis' personality, the fun prankster, and the ill, confused and despondent artist. It also just emanated a feeling of desolation, as if there was the one day when it was ok to come to remember Ian, to remember the dead — and the rest of the time, this space was forgotten and unloved, almost like the mental and physical illness that Curtis suffered in life.

I have met people from all over the world on my trips to Ian's grave. Some have become great friends, others penpals. They come from Canada, New Zealand, Japan, America, Spain... everywhere. Most people are really friendly and open, though there have been a few who thought it was weird and some sort of sad wanting to insert myself into the Curtis legend. I just think why not study Joy Division? We revere Mozart, Beethoven and a zillion other classical composers. Why *not* Joy Division?

I honestly did not ever really notice the other graves near Ian's. The only one I ever took interest in was a German fan, Cornelia, who is buried near him [see page 50 for that whole legend]. Overall, the items on the Curtis stone take over all the other kerbs in the area. As far as other famous people, there were people who had been of note in their time buried in Macclesfield Cemetery, but I was not familiar with any of them — I am sure the same thing will happen for Curtis in a century or so.

I usually would get to the cemetery, go into the office and have a natter and some tea with my friend Robert [Warhurst, see also page 89] who works there, ask if there had been any new fans spotted and spoken to since my last visit. Then I would go out to Ian's grave. I had a sheet where I made notes and kept track of what had

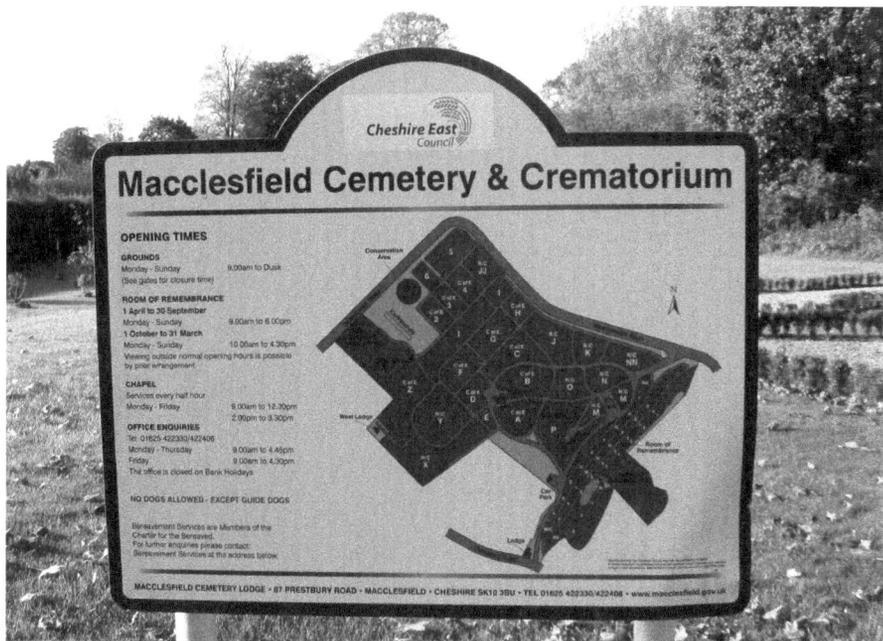

been added, taken away or decomposed from visit to visit. My whole time at the cemetery might be less than an hour; once in a while, I would be there for a couple of hours, more just kind of silently thanking Ian and Joy Division and the universe for the whole project, and in disbelief that this swim rat from Santa Cruz was actually able to do this project. It was very humbling. People get freaked out by graveyards; but I find them incredibly peaceful and beautiful. Some of my most meditative moments since arriving in the UK took place there — where things are still enough for you to stop for a minute, and appreciate the finality of death, and thus appreciate the movement, opportunity and freedom of life.

I have been to a lot of celebrity graves, ranging from the granddaddies of them all, Elvis Presley and Jim Morrison, to Sylvia Plath and Jane Austen. The first two celebrities, and even people like Marilyn Monroe — they are much bigger in death than in life, which is similar to Curtis; however, their graves are a tourist destination in themselves, almost separated from the ideas, person and canon of the actual performer. I went to Morrison's grave several years ago. It was a Wednesday in September. There were about 150 people milling around his grave, all taking pictures and there because it was a tourist destination, not because it was Jim Morrison. I even heard several people asking who Morrison was — A famous chef? A muppet creator? It was about seeing and going to the grave, not about any sort of homage to Morrison.

Plath is a lot like Curtis in that you do not accidentally end up in Heptonstall (where she is buried) just as you don't stumble upon Curtis in Macclesfield. The fan is there because of the appreciation and connection with the legend and the artist.

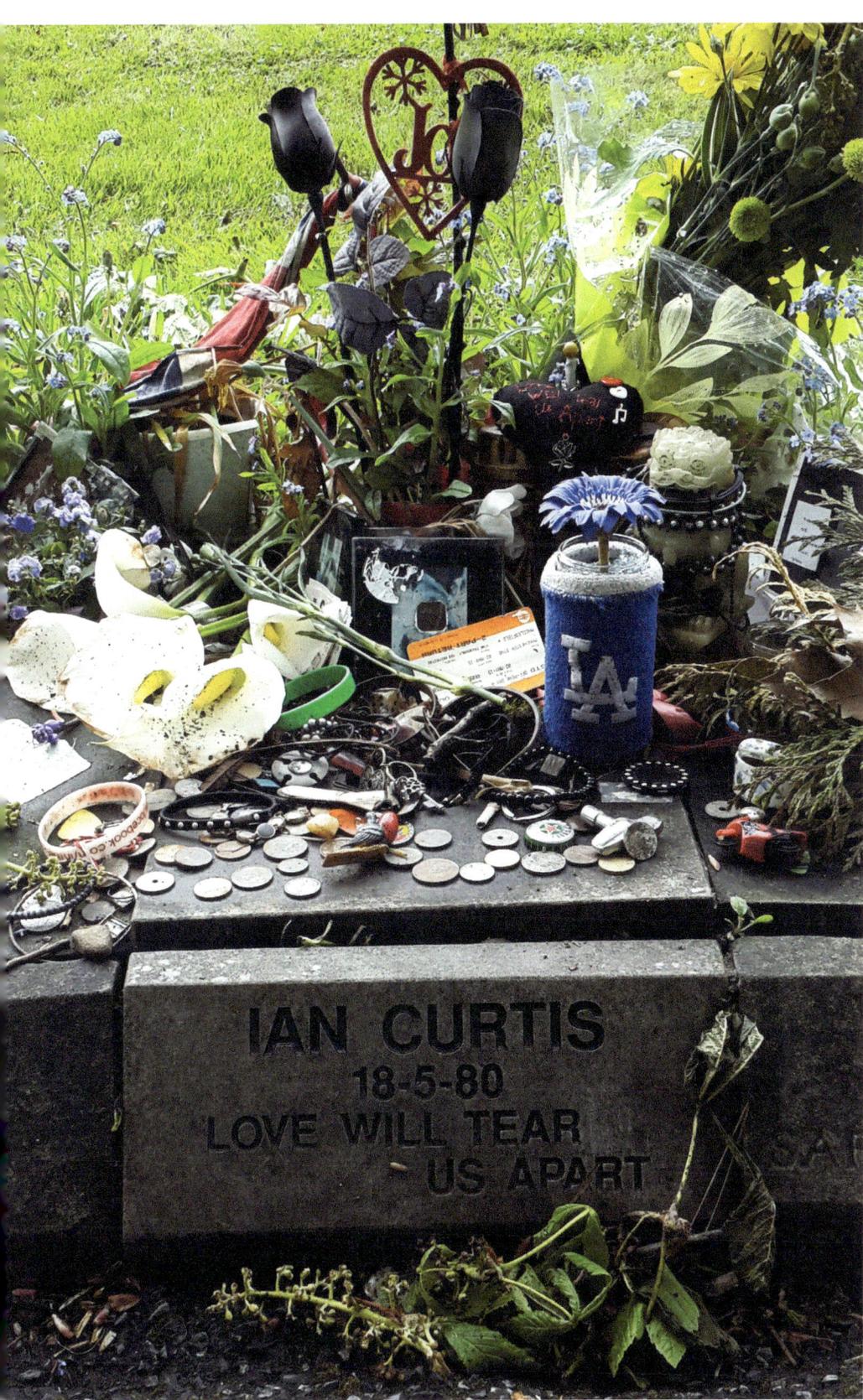

IAN CURTIS
18-5-80
LOVE WILL TEAR
US APART

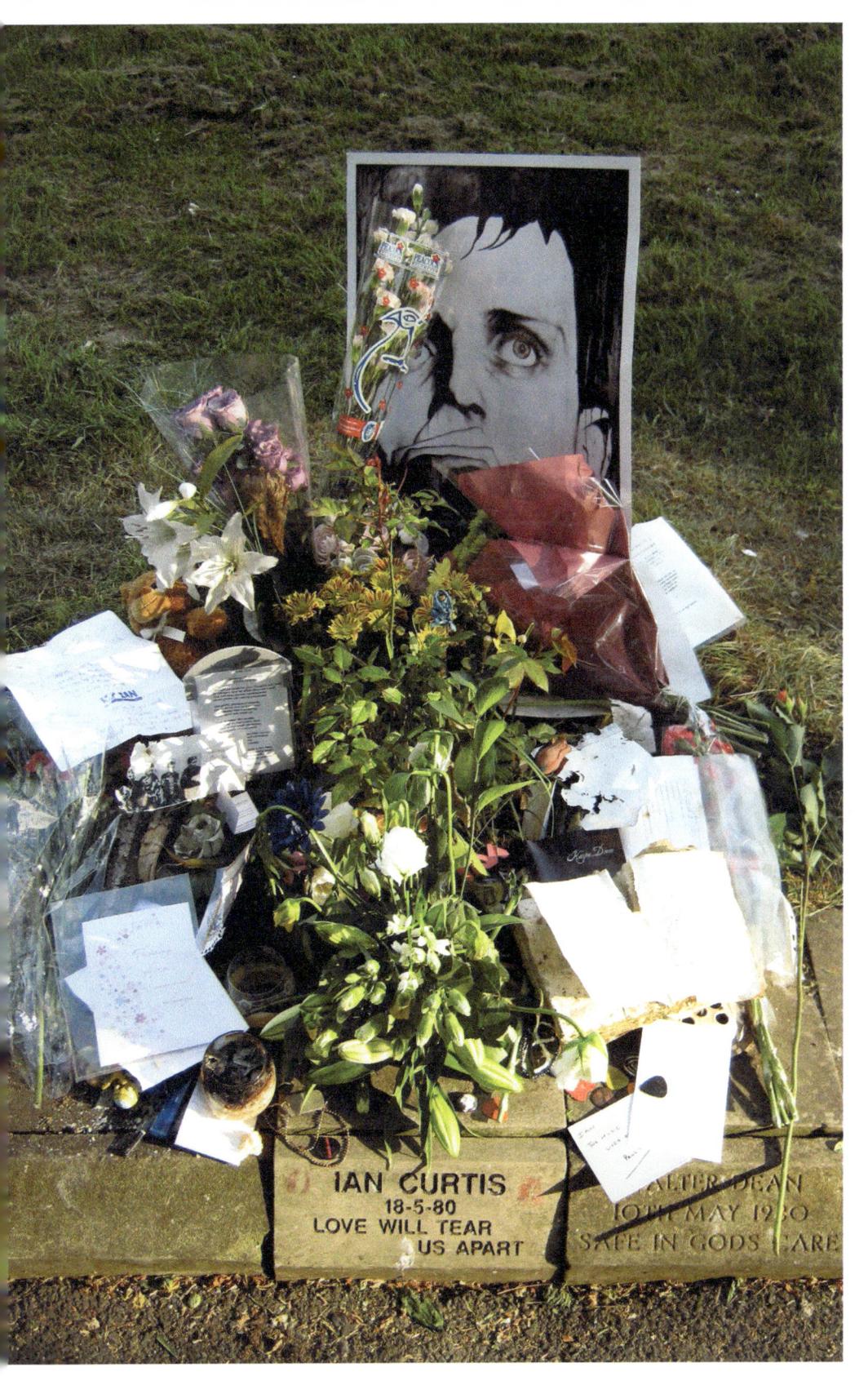

IAN CURTIS
18-5-80
LOVE WILL TEAR
US APART

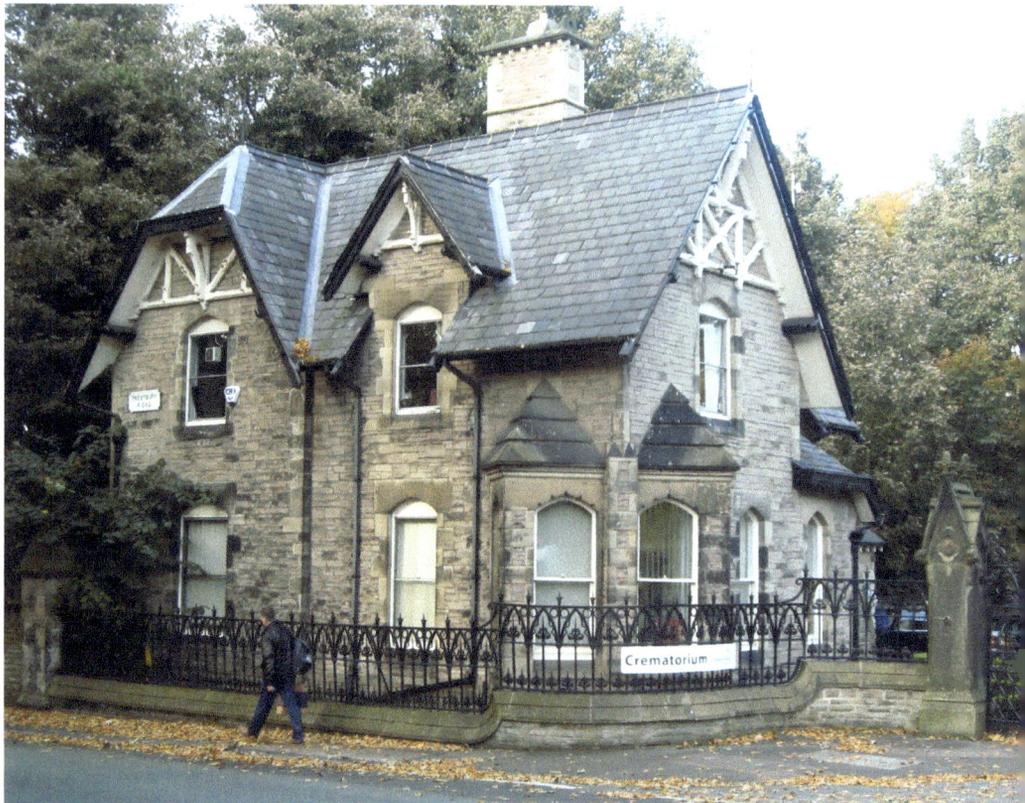

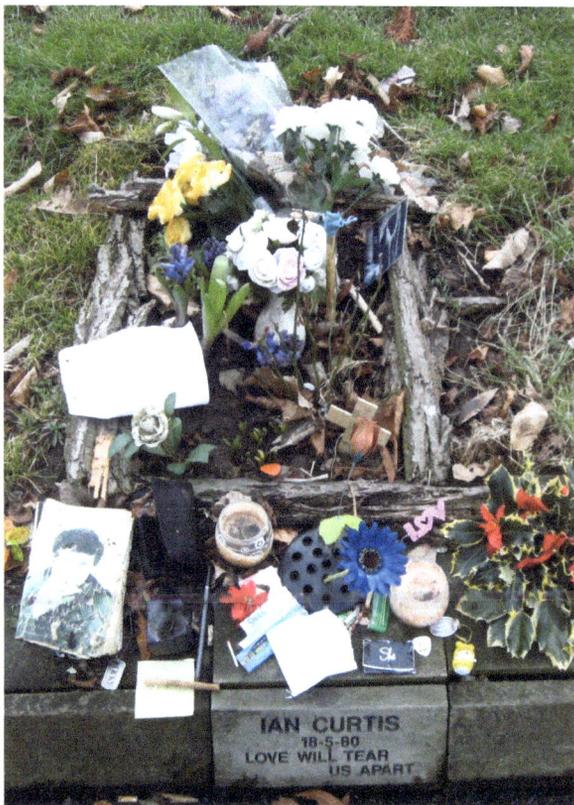

IAN CURTIS
18-5-80
LOVE WILL TEAR
US APART

'love will tear us apart'

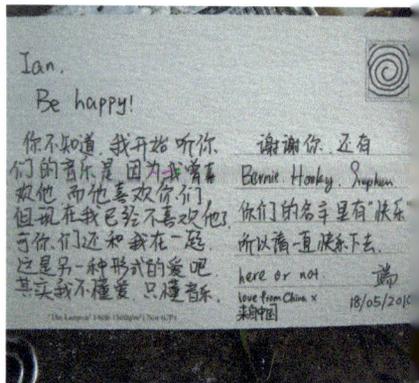

Ian.
Be happy!

你不知道 我开始 听你
们的音乐 是 因为我猜喜
欢他 而他喜欢你们
但现在我已经不喜欢他
了你.们还 和 我在一起
这是另一种形式的爱吧
其实我不懂爱 只懂音乐

谢谢你. 还有
Bernie. Honky. Stephen
你们的名字里有"快乐"
所以请一直快乐下去

here or not
love from China x        18/05/2010
来自中国

IAN CURTIS
18-5-80
LOVE WILL TEAR
US APART

NORAH KITSON
CORNFORTH
DIED 14th JUNE 2001
AGED 89
DAUGHTER OF
HARRIET and JOSEPH
CORNFORTH

For 25 years
One of Her Majesty's
Inspectors of Schools

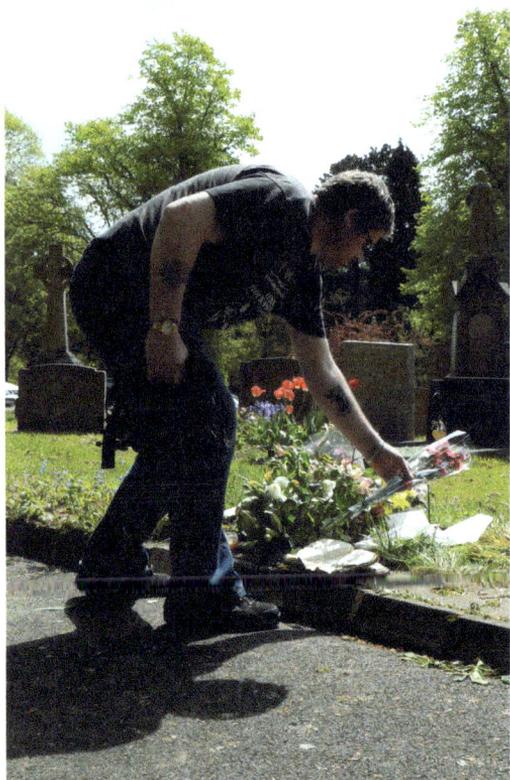

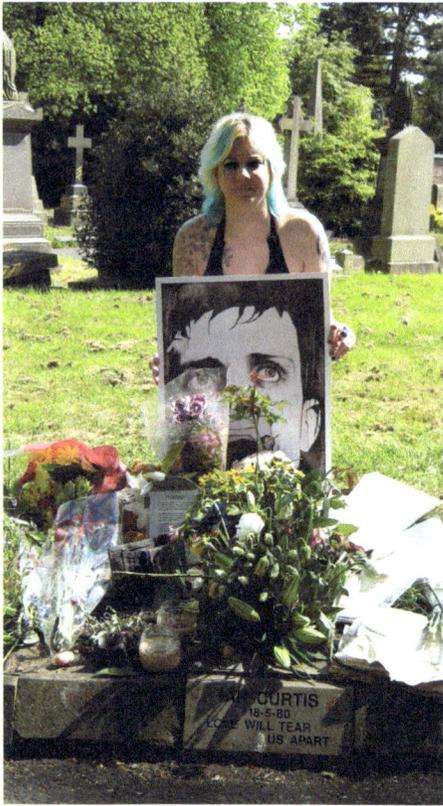

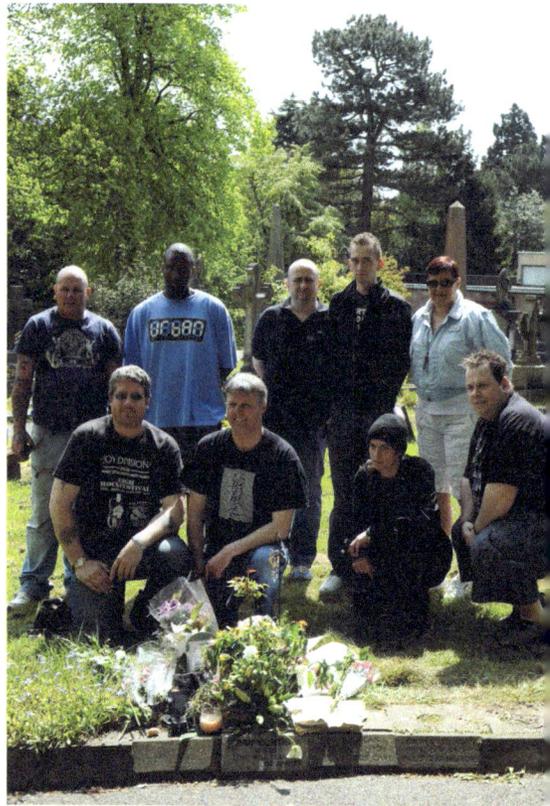

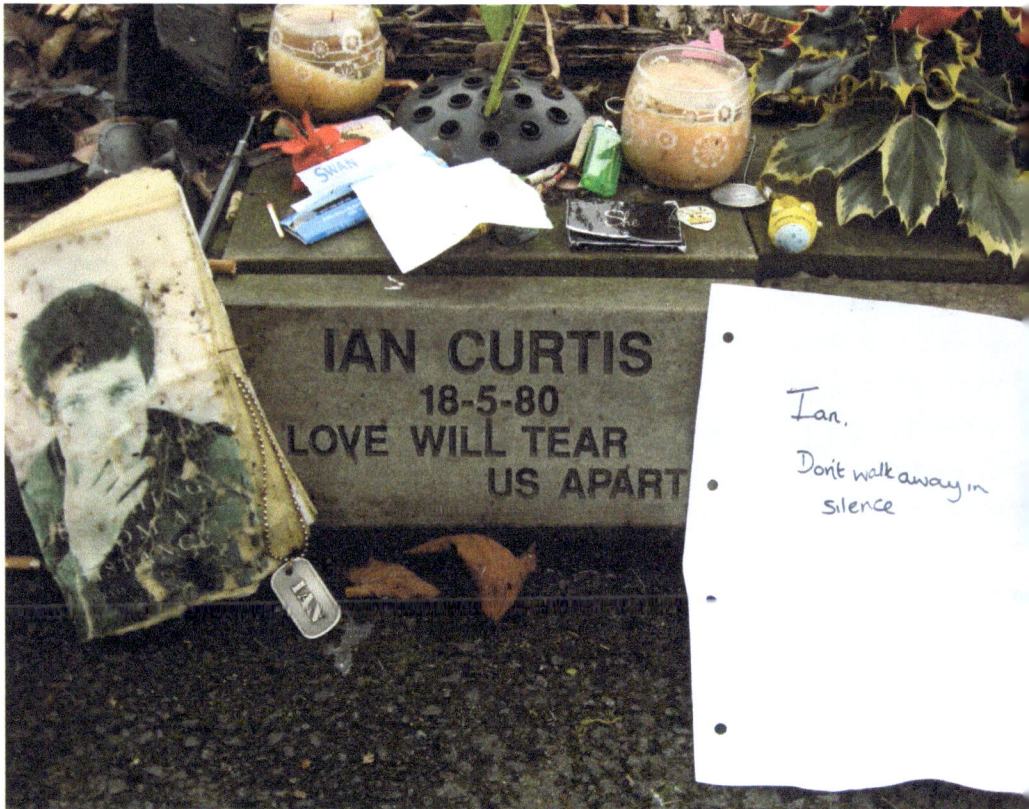

IAN CURTIS
18-5-80
LOVE WILL TEAR
US APART

Ian.
Don't walk away in
silence

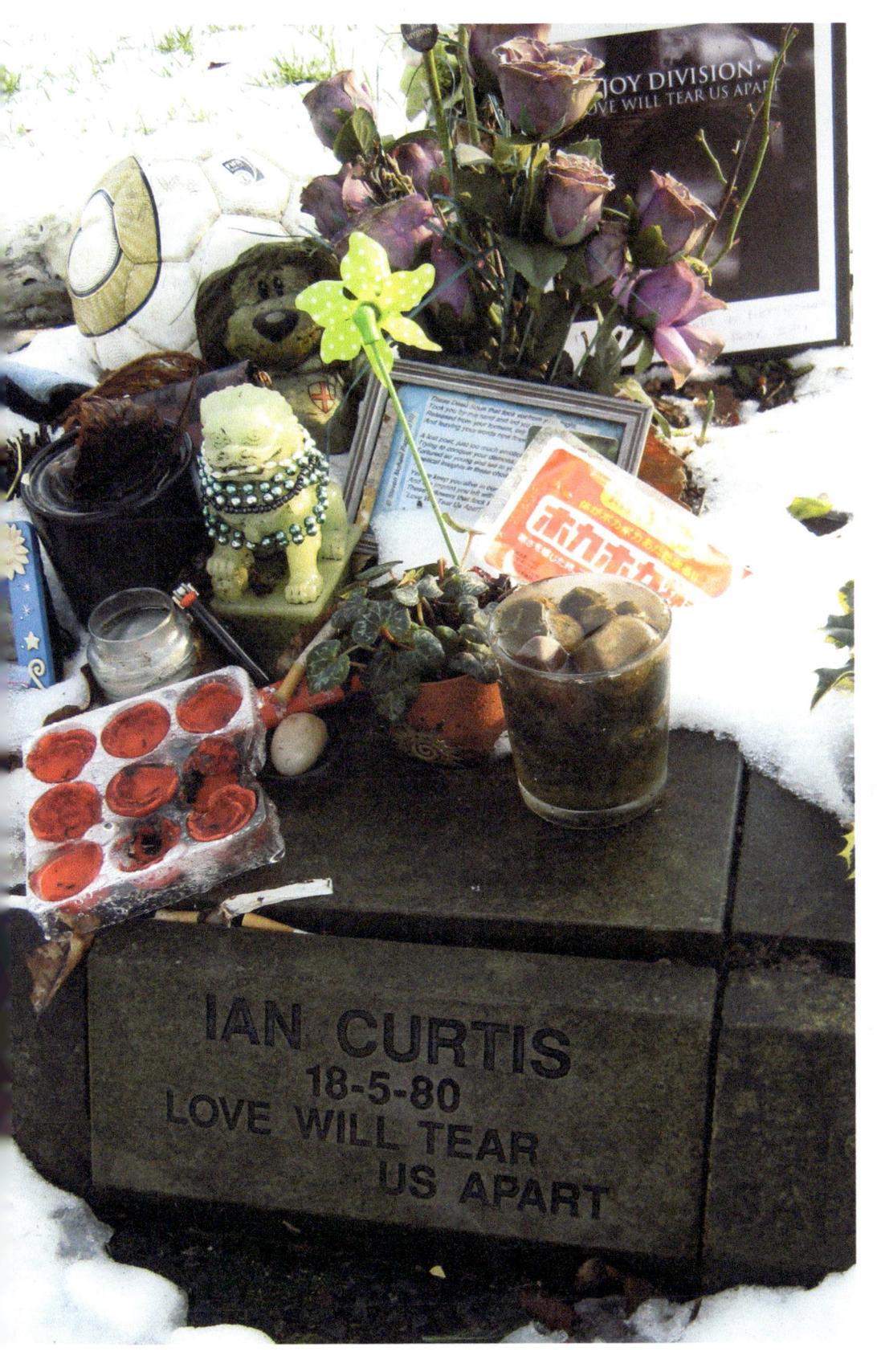

JOY DIVISION
LOVE WILL TEAR US APART

IAN CURTIS
18-5-80
LOVE WILL TEAR
US APART

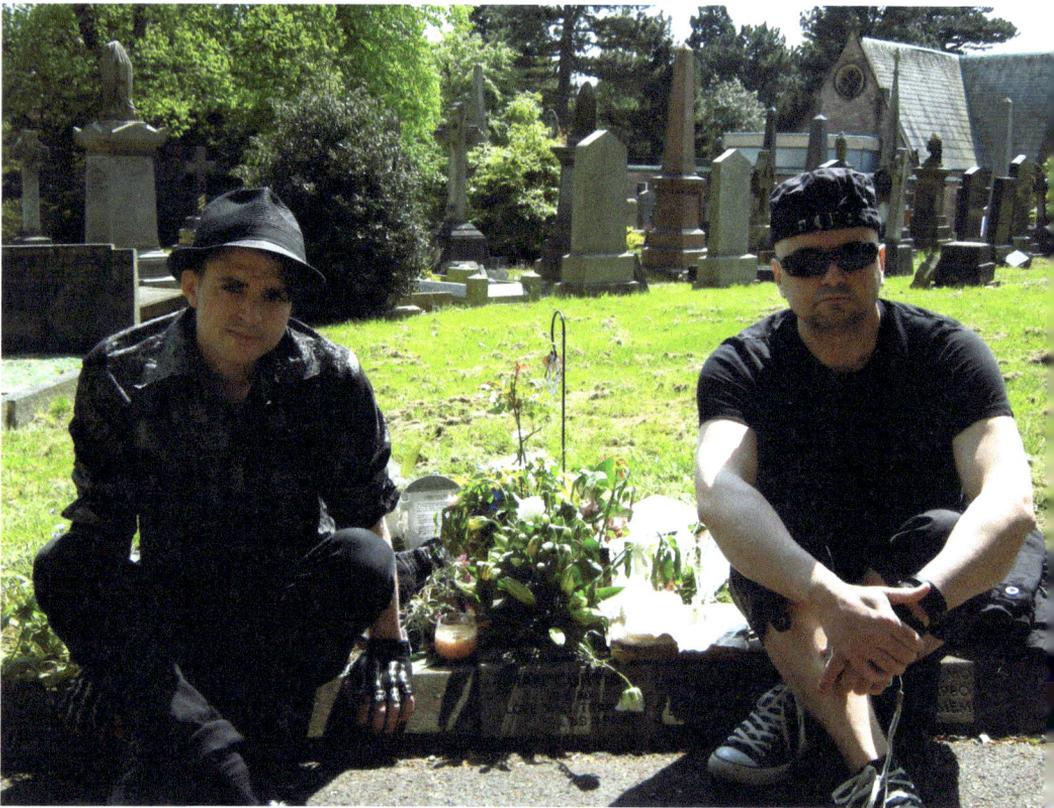

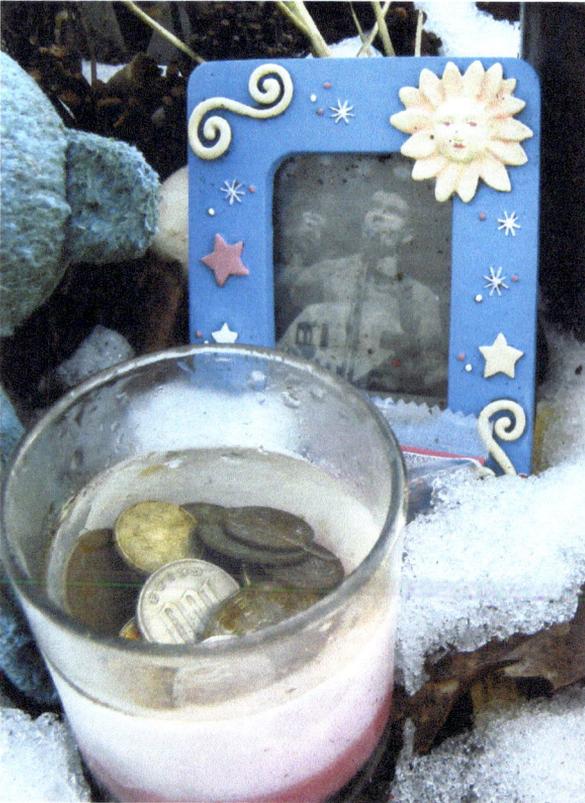

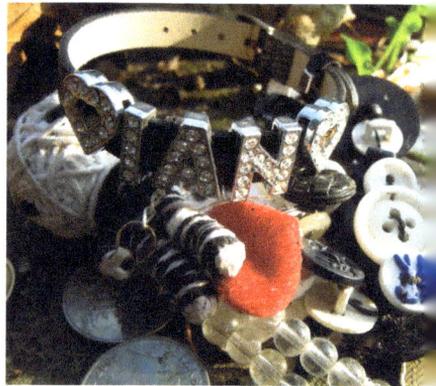

# FROM PIPS TO THE HAÇIENDA

## Punk. Joy Division. Identity.

**PHILIP KISZELY & DAVE BOOTH**

7PM MAY 18, 2012
MAL MAISON HOTEL,
PETER ST. MANCHESTER

'**M**anchester found an identity,' says Peter Hook, 'once punk started.' Looking out from his hotel room window at a city that has, in the intervening decades since the punk explosion, become a byword for musical flare and individuality, he gets right down to cases.

'The thing is,' he says, 'it's very enviable, Manchester, in that it has such a huge presence in England. Every other fuckin' town, they all hate Manchester. It's got such a musical heritage that nobody can usurp. It must be fuckin' annoying! Because it doesn't even try hard, Manchester, but it still manages to pull it off.'

We are talking in a hotel room because Hooky is staying in town tonight. We are lucky to catch him at all to tell the truth; later this evening he is due to perform with the Light at his club, the newly-opened Factory on Princess Street, and today marks the anniversary of Ian Curtis' death. A big day all round.

It might be the time and place or perhaps it is something to do with the fact we have just been reminiscing about Pips Disco, the legendary Manchester nightclub and venue for the first ever Joy Division gig. Maybe it is all of those things or none of them — he's not an easy guy to read. Whatever his motivation, he seems happy enough to talk us back through the glory days for a while. And God knows we are both content to go along for the ride. To hear about people since lost and times long gone and just how much some of it means to him.

'There are many things that are very important, but trust and loyalty are two main ones in life, really. And that's what I

loved about Rob Gretton and Tony Wilson — they showed an amazing amount of loyalty to Manchester as a place.'

This dedication helped mobilize exciting processes of change on several fronts. It was, after all, Gretton and Wilson who helped position Hook and his Joy Division counterparts at the vanguard of the new music. Similarly, their Factory Records ethos drove a re-imagining and consequent revaluation of the wider local scene. Later, on the back of the band's critical acclaim and the label's enviable roster, the buzz that made their club, the Haçienda, *the* place to be seen on a Saturday night played its part too.

In some respects the last ingredient in that mix, the Haçienda, was as much a part of the Joy Division/Factory legacy as product like *Love Will Tear Us Apart* or Peter Saville's taste-making sleeve designs. Bound up as the club was in the band's Factory Records heritage, on the one hand, and with New Order on the other (the latter being Joy Division's second incarnation, of course, and a co-investor in the club), the Haçienda became something of a defining feature of the city. To understand the extent of this local prominence, by the way, look no further than the leader of the City Council's extraordinary defence of the club when it came under threat of closure from magistrates and police in the mid-1990s. 'The Haçienda is to Manchester what Michelangelo's David is to Florence,' said Graham Stringer, with tongue placed only partially in cheek.

Stringer is over-gilding the lily here, you might think. And of course you would be right. Yet, hyperbole notwithstanding,

there is still a case to be answered. Almost single-handedly, or so it seemed to some at the time, the club managed to stimulate interest in Manchester as a youth culture destination. In turn this prompted the city's Visitor and Convention Bureau to feature the Haçienda in its promotional materials which was a novel exercise in marketing, not least because the club was rather famously reviled as a den of vice by some civic leaders and God-fearing senior policemen. Despite the comic absurdity of the situation, results were evident. The Haçienda played an intrinsic part in the city's transformation; Manchester really did dance much of its creative industries-led renaissance around the totem of FAC51, bizarre as that now may seem.

Following Hooky's gaze out of the hotel room window, we see the light beginning to fade. It is a warm evening in late spring, so the window is open. Things outside are beginning to stir. You can hear it; the night-time economy is kicking into gear. Sitting here, the conversation having taken the turn it has, we can't help but summon memories of 1989, the Second Summer of Love, of revellers queuing round the block to gain entry to a club that is the hub of the 'Madchester' phenomenon. They came, they partied, from all over the country. And here's the thing: many of them stayed to set up home here in the city. So, bearing this in mind, we try to get to the heart of the matter. Just what was the Haçienda's fundamental contribution to Manchester's punk-imbued rebirth?

In true punk style, attitude and originality played their parts. 'The thing

HAÇIENDA

FAC 51

SECOND BIRTHDAY

MONDAY 21 MAY

others in similar and different spheres would adapt accordingly. The Haçienda blazed a trail, then, which resulted in a city-wide move to transform derelict factory and mill properties into innovative city centre living, work and leisure spaces. New-build was out; brutalist monstrosities like the Arndale Centre and Hulme Crescents were ever-present and painful reminders of how not to do it. Authenticity was all the rage. The emphasis was on reconfiguration and industrial chic — old spaces for new uses. And by the early nineties people were pouring into the city in their droves to claim a piece of it. Affecting profound change on this scale was remarkable enough; managing to retain and crystallize the essence of old Manchester in the process was something else again. That, perhaps, is where the love worked its magic.

A major part of the club's attraction was its utter embodiment of the contemporary moment, sure. But there was also, it is equally important to note, the allure of its tangible punk rock heritage. The Situationist, Dada-esque craziness. Factory's direct punk lineage helped to further define its brand and lend prestige to its later output. The release of *A Factory Sampler* (1978), produced by Martin Hannett who had made his name with Buzzcocks' *Spiral Scratch* EP, kick-started an early catalogue that would include releases by acts as influential as Joy Division, Durutti Column and A Certain Ratio. This music, as much as anything else, almost magically bestowed another kind of authenticity on Wilson, Saville and New Order, along with the others linked to Factory Records.

about the Haçienda was that it was a very unusual cocktail,' says Hook. 'It was head and shoulders above everything else that was going on in Manchester.' Yet, for all that eccentric appeal, the club took its sweet time to bed in; only with the incorporation of key New York disco and Ibiza ecstasy elements would it truly round out its character. Here is the key issue, though, and fanciful as it may seem there is more than a grain of truth in what Hook says: 'Everything else was done for money; the Haçienda was done for love.'

By taking a moribund industrial aesthetic, re-contextualizing it, and then celebrating it for all it was worth, the club provided a template for design that

## 3PM DECEMBER 28, 2014 KELHAM ISLAND, SHEFFIELD

The majority of the population of Sheffield, South Yorkshire, seem to be spending the post-Christmas lull crammed into a small number of café bars. They all look the same — the café bars that is, not the people. Taking in the immediate surroundings, you would be forgiven for thinking you were sipping your flat white in Manchester. This is not the Cornerhouse, neither is it some delightful little spot in the Northern Quarter. Haçienda-approved design tropes seem to be everywhere, however, and so complete is the effect that we find ourselves sitting here comparing this particular watering hole to any number of similar establishments in Didsbury and Chorlton.

We kick this around for a while. We have met up today to talk about writing this very chapter, so Manchester is dominating our thoughts and, we suspect, colouring much of what we see. Even so, despite their difference, it is fair to say that Sheffield and its illustrious neighbour have much in common. Cross-fertilisation or homogenisation, frame it how you will, elements of the Joy Division/Factory aesthetic have become ubiquitous in English northern towns. There are a myriad of different and evolving takes on the theme, of course, and Steel City does no doubt stake its own claim to originality in the industrial chic stakes, but the similarity is nonetheless marked for all that. Let's, then, for the sake of argument, trace the source back across Snake Pass, through Glossop, and into heart of

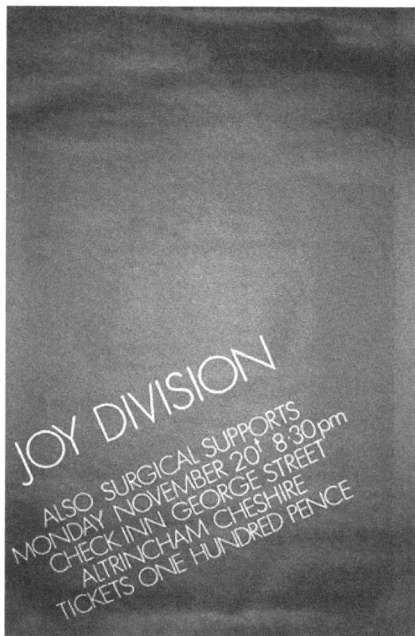

Manchester city centre. Let's travel right down through the years to punk and Joy Division, because that way we get to uncover some lovely stories of transition.

In broad terms, change in Manchester manifested itself most tangibly in a shift from the industrial to the post-industrial, as evidenced eventually by the Haçienda and its previously noted place in the overall scheme of things. On a personal level, involvement by the city's young people in a nascent music scene prompted a shift in emphasis from the national industry to localized DIY subcultures. The difference here is fundamental: a move from passive to active. Many Mancunians seem to remember their participation in the punk and the post-punk eras with remarkable ease. Their precision of recall adds weight somehow to the otherwise fanciful notion that the emergence of the local scene reflected and drove their own changes.

'I was at the [Joy Division] gig at the Check Inn nightclub in Altrincham on Monday, November 20, 1978,' says fan Winnie Stack. 'I was in the lower sixth at Loreto Convent in Altrincham, and had turned sixteen some five months previously.

'I can remember it didn't seem to be very crowded. I stood about halfway back; I wasn't brave enough to go to the front. But my view of the stage was un-obscured, as was Curtis' view of me... And I convinced myself he was looking at me... His gaze and performance were intense. I can remember him dancing: the tension in his body, his arms flaying about, reminiscent of the drummer boy on the cover of their *Ideal for Living* EP. I wasn't watching anyone else in the band: just him.

'I'd spent my early teenage years adoring David Essex and David Cassidy... Big, faraway stars whose worlds would never-in-a-million-years collide with mine. Punk had changed that. The "stars" were no longer out of my reach. They were in my backyard. Their world and my world were not so different anymore. It strikes me that this coincided with my own developing sense of autonomy. No longer was I a child, a passive observer; I was growing up, leaving my childhood behind, setting my own agenda, becoming a participant...'

Our discussion in the café bar at Kelham Island, Sheffield, turns eventually to Pips Disco, just as it had two years previously with Peter Hook at the hotel on Peter St., Manchester. Perhaps this is because Pips marks an embarkation point of sorts. It was here, after all, on January 25, 1978, that the band previously known as the Stiff Kittens and then Warsaw debuted as Joy Division.

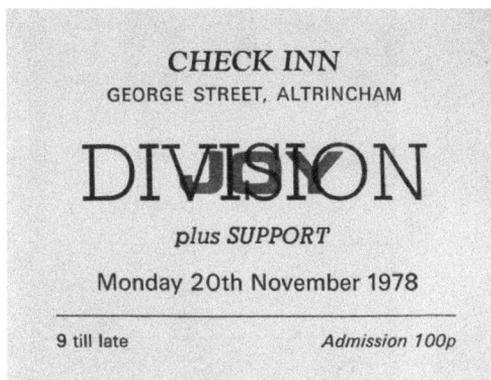

**CHECK INN**
GEORGE STREET, ALTRINCHAM

# DIVISION

*plus* SUPPORT

Monday 20th November 1978

9 till late                    Admission 100p

Rather confusingly, they were billed as Warsaw for the Pips gig; the name change occurred after the flyers were photocopied, but it was third time lucky and it stuck. Suicide will eventually force a fourth and final name on the band, but that particular tragedy, thankfully, is beyond our scope here. We are concerned with inception, not rebirth, and so we return back to that night at Pips and the heady days of punk.

Colin Blades was the sound engineer for that first Pips gig. 'Pips was home to the Roxy Room (my old haunt), and one of the few clubs that dared play new music, so choosing it was very apt,' he says. 'There was a little audience trouble at this gig, but it was soon snuffed out. I believe the affray was mostly down to first time gig revellers believing that that was "the thing to do".'

The odd teenage scuffle notwithstanding, nightspots like the Roxy Room at Pips and the Ranch Bar, a punk-dedicated room in drag queen Frank 'Foo Foo' Lamarr's nightclub, were havens. Along with live music venues like the Electric Circus, they would provide safe arenas in which young punks like Winnie Stack could explore their emergent identities.

Recalling        the        aforementioned Altrincham Check Inn gig specifically,

she says: 'I wore an angora loosely-knitted jumper: one side pink, the other grey, and silver lurex footless tights, and that was all, except for some kitten heels. I don't know where I found them. The jumper I'd bought in Manchester. It came to just below my bum. I don't think my dad saw me leaving the house... It was a deliberate strategy: I put my sex on show. That was what would gain me entry to the "scene". It was my currency.'

Debra Madden shares similar experience of emergent personas and a community forming: 'I got into punk whilst at school in 1976, after meeting other Moston and Salford punks in Piccadilly Gardens. As a Bowie fan, it all fitted together.'

Her memories revolve around the Electric Circus: 'Many of the people at the Electric Circus were those I knew: punks from Manchester, but also students and older people — hippy types. I saw gigs at the Circus mainly on a Sunday night. I was a Buzzcocks fan, so I looked out for them playing. For Joy Division (Warsaw) we

arrived early because we were at school the next day. I recall they said, 'Hey, we've got an audience' and clapped when my friend and I walked in. It was early. 7-ish, I think. Dick Witts was there, a Mancunian musician and journalist. And people I knew through Buzzcocks, like Richard Boon.'

Three cups of coffee down, a sandwich and the obligatory Jenga-style piled fries on the way, and the comparisons between Sheffield and Manchester prompt a mention of Salford. Inevitable, really, and Debra Madden's recollections of Salford punks in Piccadilly Gardens provide further food for thought. Close proximity to Manchester, coupled with a resultant blurring of boundaries in pop culture identity, has done few favours for Salford as a city. Even with its shiny and new Media City, Salford struggles in terms of differentiation, and experiences problems in establishing itself in the popular imagination. It is a fairly safe assumption that, for the majority of the arts- and media-types populating this café bar right now, the image that endures is that of the Smiths hanging around outside Salford Lads Club. And what does that translate to? Why, a Manchester band slumming it, of course. The reality, as so often is the case with comparisons between sister cities like Manchester and Salford, is somewhat different.

If a handful of early shows capture the spirit of the embryonic punk scene, then the Salford Technical College gig of early October 1977 must rate as prominent. Warsaw featured on a lineup which read like a 'Who's Who' of local cool, including as it did Slaughter & the Dogs, the Drones, Fastbreeder, and V2. Joy Division would

often describe itself as a Salford band, it must be remembered, so Salford Tech was home turf.

'It was Friday 7<sup>th</sup> October,' says fan Debra Allan. 'It cost 75p (I still have half the ticket). Warsaw. I thought they were pretty bad, as I recall… My memories are more of the crowd — getting a pint bought for me by scary looking punks. The drink was ale and it tasted disgusting. What I will never forget is that those same "scary" punks were horrified that I was there on my own and gave me money for a taxi home as they didn't want me getting a late bus alone. How sweet is that?!'

Manchester, Salford, Sheffield. Reputations are notoriously difficult to chart, especially when the mapping is dependent on something as frivolous as pop culture. One thing is for certain, though, and that is that punk did one thing remarkably well: it brought people together.

Sound engineer Colin Blades also worked with Manchester band Emergency/Foreign Press, who shared rehearsal space with Joy Division at 35 Little Peter St. He remembers the place as a thriving hub: 'The building housed a number of Manchester bands who were busying themselves in readiness to ride the forthcoming new wave of punk.' The names he recites — V2, Slaughter and the Dogs, the Frantic Elevators — are now the stuff of legend.

But it was from behind the mixing desk that Colin witnessed Joy Division play all over the local scene from Bury to Altrincham, and all stops in between. He saw the troubled nature of Ian Curtis' character play itself out in various ways, of course he did. He also saw another side. 'I don't want to leave the impression Ian was a dour

character,' he says. 'On the contrary, he had a terrific sense of humour and was easy to chat to, which we did on a number of occasions. The conversation usually centred on music and especially Bowie, Reed and Iggy — we were both fans of the aforementioned.'

He often saw the band having fun, too. July 28, 1979, at the Mayflower 'Superstars all-dayer', is particularly vivid for him in this respect: 'One of my best memories of Ian occurred during this gig, just after Joy Division had completed their soundcheck and left the stage. Hooky bent Ian over a table and shouted over, 'Look, I'm stuffing a superstar!' with Ian pulling the appropriate faces.'

## FEBRUARY 15, 2015
## WALKLEY LANE, SHEFFIELD

I (Philip) get a call from Dave. I am sat at home, looking through the interview materials for this chapter. Both of us, on and off over the last couple of weeks, have been sifting the transcriptions, together and independently. Dave tells me he is hosting another Pips Disco community get-together. These reunions, which happen with pleasing regularity, have been made possible by ex-Pipsters (Pipsters — that's what the old gang get called nowadays) Dave and Phil Caldwell. They set up a Facebook page a couple of years ago, and the community grew and grew. Dave is pleased, he informs me, because this time he won't be DJing alone. This time Peter Hook will be joining him.

For Joy Division, it started with that first gig at Pips. And it carries on, just the same. All the old punks. All the old dudes. All beautiful.

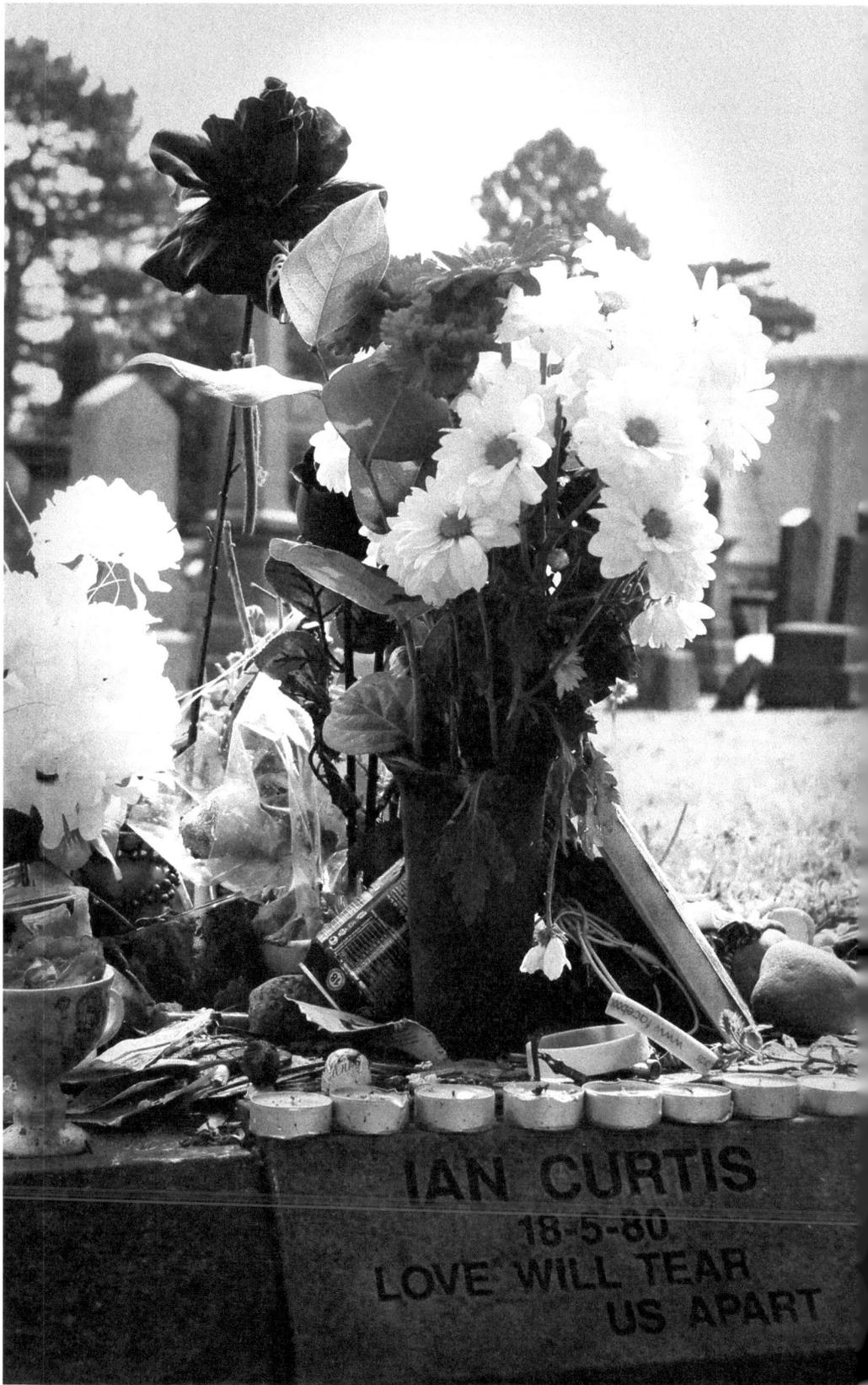

IAN CURTIS
18-5-80
LOVE WILL TEAR
US APART

# MACCLESFIELD

## IAN SEIVWRIGHT

Macclesfield: A seemingly quiet town in the shadow of its more illustrious neighbour, Manchester. Yet it is my favourite place in the whole of the United Kingdom. Why? Simple: because of Ian Curtis and the memories I have of going there every year since 1982.

The nexus formed between me and Joy Division after playing *Closer* to death on my record player. I decided that I wanted to visit Ian Curtis' grave — but didn't know where it was. In those pre-World Wide Web days, it was difficult to find things like that out (which was made even more difficult by the fact that no one had heard of Ian Curtis then!). It took me about nine months or so before I found out he was interred at Macclesfield Cemetery and Crematorium. On May 18, 1982, I took the train from London Euston to Macclesfield, paying the princely sum of £3.70 for the return ticket, and embarking on the first of many such journeys. I stayed by his 'stone' for

five hours. Only two other people came in all the time I was there. Like every year, I will be going to Macclesfield Crematorium again this May.

I have a lot to thank Ian Curtis for. His death has allowed me to 'know thyself' and find a deeper, happier and steadier equilibrium in my own existence, as well as the unshakeable confidence to go out and create my own place and niche in life.

Listening to Joy Division guided me along the path that gave me a lot of the answers I was searching for; when Ian Curtis sang, 'this is the way, step inside,' I took my first tentative steps on the journey of life. I learned the importance of humility; through the music of Joy Division, I learned to think.

Every day I listen to Joy Division and it makes me optimistic no matter what life throws at me. Thank you Ian Curtis and thank you Joy Division for filling that void during my adolescent years that might so easily have led down an unhappy and unfulfilled road. I owe you all so much as you have given me so much through your music and I will never ever forget that.

# SOMETHING MUST BREAK

## Exploring fan motivation for attending a Joy Division performance

### NEIL ROBINSON & CRISPIN DALE

Though music is a key driver for attending musical performances, it may not be the sole motivator. In a festival context, factors including social enrichment and discovery can also be influencers in attendance. Furthermore, these motivations may range from feelings of escape, excitement, novelty, socialization and family togetherness. Research has noted that attendees can enter a liminal space when going to a festival or concert, moments representing a 'time out of time', an alternative sense of reality, or 'a special place' that is perceived differently from the individual's day to day life. This change in mental state can render the individual to display emotions that are radically different from what they have exhibited before. These can be further exacerbated by alcohol and narcotic substances that can exaggerate the behaviours experienced. A moral ambiguity can detach the individual from reality. Indeed, when at a gig, a person can feel absolved from the moral pressures of these situations, resulting in a display of emotions that is different from their overall character.

Developing a sense of camaraderie is a key component of the sociability at an event experience. However, the collective consciousness of being with other gig goers can temper behaviour that results in a range of emotions. Some of these may be deviant in nature including verbal and physical aggression, riots and fighting. In this way, popular music can represent a space for identity, conformity and transgression. Wanting to claim that 'I was there', and actually experience the concert can be key in espousing an individual's identity, esteem and ego.

gigs

The Derby Hall Market Street Bury
Phone 061-761-7107.

DOORS OPEN 8.00 pm — ADVANCE TICKETS MAR JOY DIVISION

**Tues 25th Mar**
FREEFALL / CRUMPSALL

**Tues 1st April**
CERTAIN RATIO

**Tues 8th April**
JOY DIVISION
+
MINNY POPS
(Holland - 1 of 3 dates in UK)

**Tues 15th April**
NIGHT
VISITORS

**Tues 22nd April**
NO CLUB

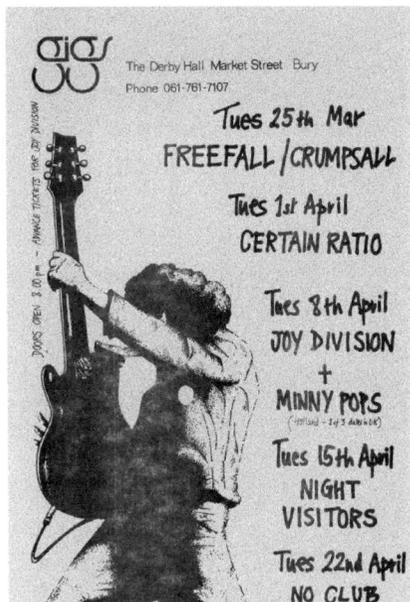

It's not uncommon for gig goers to lay claim to attending an infamous event as a means of validating the authenticity of the experience. In addition to the Joy Division Derby Hall gig (Bury), similar examples have also included the Beatles at Darwen Co-operative Hall (January 1963), T-Rex, the Move, Fleetwood Mac and Captain Beefheart at Frank Freeman's Dancing School in Kidderminster (1968–71), David Bowie, Queen and Mott the Hoople at Preston Guild Hall (circa 1970s), Dandelion Adventure in Blackpool at the Adam & Eve club (late 1980s), the Stone Roses on Spike Island (1990), and Oasis at Avenham Park, Preston (1994).

Three individuals were interviewed in an attempt to identify underpinning motivations for attending Joy Division's gig at Bury's Derby Hall on the April 8, 1980. The three attendees were initially contacted through a friend who runs a musical society in the North West of England. The individuals were interviewed in November 2014. The sample group is as follows.

**Interviewee 1** (male, fifty-four): **John** aged twenty at the time of the gig, visited gig with work mate, Dave.

**Interview 2** (female, fifty): **Mary** aged sixteen at the time of the gig, visited gig with boyfriend.

**Interview 3** (male, fifty-nine): **Trevor** aged twenty-five at the time of the gig, visited gig as a result of acting as an unofficial roadie.

# INTERVIEW ONE

John had been a fan of Joy Division for a number of years before going to watch them at the Derby Hall in Bury. He had gotten into the band via his work colleague who was a fan of Joy Division.

'My mate Dave got me into Joy Division, he was a big fan of them. He would always bring vinyls into work and let me borrow them, I started listening to them as well, all as a result of Dave.'

Whilst in the confines of work, John would engage in musical discussion with Dave, specifically about his new found interest in Joy Division. The daily rigour of his mind-numbingly tedious job was punctuated by musical discussion on the merits of supporting and following Joy Division over the other musical offerings of the day.

'The job I did back then, it was dirty, boring and very manual. If it wasn't for Dave and our discussion about music and Joy Division, I don't know what I would have done.'

It was during one of their discussions that John became aware of Joy Division doing a gig in Bury at the Derby Hall. It

79

was decided they would attend the gig together. On the night of the gig, they both met in Bury and walked up to the venue.

'Before the gig, I was a bit nervous, never having really been to a gig before. I needed a drink, I was nervous and I knew a drink would help. It was fortunate that the venue had a bar, me and Dave had a few jars before we went to watch the gig. I was determined to get drunk.'

The pre-gig drinks worked well for John; in no time at all, he felt confident and ready to watch Joy Division. Sadly his mate Dave had met a girl at the bar, left early with his newfound female friend and missed the concert.

'I couldn't believe it that my mate had stood me up for a bird. We went to the venue, got drunk and he bogged off. I was livid, but decided to watch the gig on my own.'

John decided to go it alone and to attend the gig. There were some people he recognized from work. Otherwise, John felt very excited, going by himself and watching a band he had listened to but never seen live.

'By the time I actually got into the concert hall, Joy Division had done a number of tracks. I later learnt this was without Ian Curtis, apparently Ian was reluctant to go on and the guy from Crispy Ambulance pretended to be Ian and did a number of Joy Division songs. A group of skinheads near the front got wise to the fact that Ian Curtis wasn't performing and went wild, fists everywhere, pint pots flying all over the gaff I was terrified; it was brilliant.'

The fact that he had gone alone to the gig having been let down by his mate Dave made him feel strong and independent;

this provided the stark realization that he could do anything and that he did not need Dave anymore. This resulted in him feeling an element of inner harmony. After the gig and upon leaving the venue, John stopped off for some fish and chips at the local shop. The chip shop was packed with people who were talking about the gig. He joined in telling them about his experience of the gig.

'There I was holding court in the local chippy, I was surrounded by loads of blokes and birds, all asking me about my experience. I laid it on thick, I exaggerated my role, I told 'em that I threw two skinheads over the bar and slashed a seat. Clearly I hadn't but it made me look good, the kids loved it, I felt superior, my so-called mate Dave had missed all this.'

The experience stayed with John for over a fortnight. He was totally empowered from his Derby Hall experience and the social recognition he received at work made him into some kind of urban legend.

'One day I went to the bogs at work, someone had scrawled on the wall, 'John did two skins and one seat in the same night.' I knew I had become a demigod, at least in the setting of my everyday work place. Dave and myself never really spoke about the experience of that night; ironically he married that bird he stood me up for and years later she divorced him.'

## INTERVIEW TWO

Mary visited the Joy Division gig on April 8, 1980, with her then boyfriend. Her boyfriend had been a fan for some time. Under duress she went to the Derby Hall in Bury.

TUESDAY
8th APRIL

# JOY DIVISION

* tickets *
£1 advance
£1.25 at door

Just recorded their second album on Factory Records, out at the
end of May. 2,300 at The Lyceum the other week so tickets at
The Derby an' all. Off to America in May or June. New single
LOVE WILL TEAR US APART/THESE DAYS should be out by time of this
date.

Ian Curtiss vocals vox guitar Peter Hook bass lead Bernard
Dicken lead bass synthesizer Stphen Morris drums percussion

# MINNY POPS

From Holland, electronic and wierd. Possibly recording with
Factory later. Wilson's got the sleeve so no more detail.

Tickets on sale at Derby Hall Box Office 10am to 4pm, Mondays
to Saturdays (closed Tuesday); also on the door if any left.

'This was not my idea, but my then boyfriend Kev said it would be a good night out. I would have preferred going to the cinema, but I would be out of the house and in the company of other young people… Being with my boyfriend made it all worthwhile, but he never paid for me to go out. I had to buy my own drink and pay myself in. This was money I didn't really have… This was the first gig I had ever attended, I felt initially very nervous, but then I felt brave, me and our Kev going to a gig on our own, it was a real thrill. At that time I had a very dull job and this forthcoming gig made me feel very excited, Kev had also promised to treat me to some food at the gig.'

During the evening, Mary detailed how they had arrived early and they had both stood at the front waiting for the show to start. Kev had bought her a hot dog. Mary felt somewhat let down by the food provision as she was expecting a sit down meal and not a hot dog. However, all was not lost as Mary experienced being star

struck having briefly seen Tony Wilson at the gig.

'I saw this chap peeking from behind the curtain, I am sure he winked at me. Our Kev later told me it was the chap off Granada TV regional news Tony Wilson and head of Factory Records. I couldn't believe it, I really fancied him.'

It took quite some time for the support act to warm up (Crispy Ambulance) and Mary decided to quickly visit the bar:

'I was getting bored. Kev stayed at the front and I went to the bar. It took ages for me to get served. When I got back, the venue was in pandemonium. I couldn't see Kev, people were on stage fighting.'

At this point, Mary viewed Kevin at the other side of the stage lying on his back; Mary ran over and noticed that Kevin had been knocked unconscious.

'I saw Kevin lying on his back, he looked really unwell. I ran over and helped him to his feet, we left via a fire exit. I saw a load of police vans arriving. When we got outside, Kev said I was brilliant, he told

me that he had been hit on the head and collapsed. I felt really brave having helped Kev. Kev kissed me and said I was a hero, I felt alive, thrilled by my experience. I had never done or experienced anything like that in my life; this was exciting.'

Post gig and some days later, Mary went back to the venue and got a partial refund on the show as a result of it ending sooner than was planned. The subsequent confidence and hero-like status that Mary had experienced during and after the gig enabled her to better realize how independent she was from Kev. After the events of April 8, 1980, Mary decided to leave Kevin and move on.

'The events of that evening showed me how dependent upon Kev I had become. He controlled every part of my life. I went to a gig that I didn't want to attend, I had to buy my own drinks and all I got was a lousy hot dog. Having saved Kev from getting his head kicked in, I suddenly felt brave and strong as though I could live my life without Kev. It was at that point

I decided to end our relationship and I have never looked back. I am now much more confident and stronger and won't be messed about by men. Years later, I am now more independent and have greater respect for myself.'

## INTERVIEW THREE

Trevor (or Trev as he liked to be known) had, for a number of years, acted as an unofficial roadie and bouncer at the Derby Hall. On the night of April 8, 1980, Trev turned up early looking for some roadie work:

'I often used to work at the Derby Hall as a bouncer dealing with drunken fans and also as roadie moving heavy equipment for the bands. On that night, I popped into the Derby Hall to see if they needed any help. They immediately asked me to do some roadying. I got cash in hand and I could pick up girls; they loved us roadies.'

Upon further discussion, Trev made it clear that back in those days he had been a bit of a ladies man, and used to like to drink and fight. Trev would often see himself as a hard biker-love-on-the-run type.

'Back in those days, I was a real lad, well-known in the Bury area. I could handle myself, drink loads and get the birds.'

During the gig, Trev was allowed as much free booze as he wanted, as long as he ensured the venue was kept in order. This would often result in Trev getting drunk, making him feel happy and free from the daily shackles of his unrewarding day job.

'I loved my night job back in those days, loads to drink, do what I like and sometimes a right good punch up. I would often feel free, I hated my day job. The

night job allowed me to dream, feel happy and free.'

By the time Joy Division got on stage, the venue was full. A group of skinheads had turned up and started causing problems. Apparently Joy Division had only done a few tracks with Ian Curtis on stage and this angered some of the audience. A fight ensued and people started getting on stage. Trev stepped in, punches were exchanged and the police were called.

'Apparently some of the audience was hellbent on causing trouble, skins I suspect. A load got on stage and started fighting. I weighed in, I bashed a few of 'em and dragged two out via the emergency exit. It was great; I was having a right laugh. Unbeknown to me, two coppers grabbed me outside whilst I was sorting these blokes out. I ended up chinning two coppers. Seems funny now, but it got me arrested, a fine and a record for affray. That said, every cloud has a silver lining: the management at the Derby Hall heard about my actions and paid my fine. I got extra work doing the doors at the Derby Hall. For weeks later, ladies were asking me about the night I sorted two skinheads out and chinned two coppers.'

The interviews suggest that attending musical performances is based on a number of factors; the specific motivations for attending a Joy Division gig are themselves complex and multilayered. Though thirty-five years since the gig, memories still hold clearly for the interviewees. The analysis has revealed a number of key themes with excitement and social recognition being the most pronounced.

The subsequent riot became a performance in its own right. The act of 'moshing' at a performance can also be viewed similarly. The fact that the gig is still discussed and has, among Joy Division fans, become legendary in status, suggests that the riot is part of the wider performance itself. The show provides fans who claimed to be there with their own stage on which to espouse their superiority, ego and quasi-celebrity status. The interviewees' presence at the gig has legitimized their motivations and identity. The emerging counter fan cultures of skinheads versus new wave at the time resulted in a combination of protecting territory and identity. The expression of 'I was there' offers cultural capital where potentially there is a display of mythology and status attached to attendance at such an infamous gig. In the present-day context, music performances can be captured on video with the instant display on social media channels for all to see. Such imagery authenticates attendance at the event. Performances prior to the immediacy of this technology are driven by fan folklore and storytelling catapulting the fan to the status of the artist they had gone to see. However, the extent to which this can be authenticated is debatable, potentially exaggerating events that occurred and perpetuating mythology behind it. It is undeniable that via representations in popular culture and media, Ian Curtis has become immortalized as representing a tortured individual, one who had a combination of physical and mental challenges to deal with. Attendance at the gig has been part of that immortalization process, enabling association to the lead singer, band and what they continue to represent.

SEEING THE SEX PISTOLS WAS CONFIRMATION THAT THERE WAS SOMETHING OUT THERE FOR HIM OTHER THAN A CAREER IN THE CIVIL SERVICE.

THEY REAFFIRMED IAN'S BELIEF THAT ANYONE COULD BECOME A ROCK STAR.

IT SEEMED AS IF WE HAD ALL BEEN ISSUED WITH INSTRUCTIONS, AND NOW WE WERE SET TO EMBARK ON A MISSION.

"I'VE BEEN WAITING FOR A GUIDE TO COME AND TAKE ME BY THE HAND..."

16.

# NEW DAWN FADES

## A play about Joy Division

### BRIAN GORMAN
### (AS TOLD TO JENNIFER OTTER BICKERDIKE)

I n 2007 I began researching a graphic novel about the history of Manchester and Salford. I'd just moved to Salford, and became fascinated by the history of the area. A friend of mine, the multi-award winning novelist Bryan Talbot, had recently had huge success with a graphic novel called *Alice in Sunderland*, which covered the entire history of the town, in this case, Sunderland. I decided I would like to do a similar book on Salford and Manchester. TV and music legend Tony Wilson was one of the figures I wanted to feature prominently in the book. When I was looking through video clips of him on YouTube, I came across Joy Division. I'd been aware of the band for decades, and I was a big fan of New Order in the 1980s, but was only vaguely aware they were essentially the same band. The moment I saw Ian Curtis singing *Transmission*, I was blown away. I'd never seen anything like it; both hilarious and disturbing at the same time. I immediately bought the two

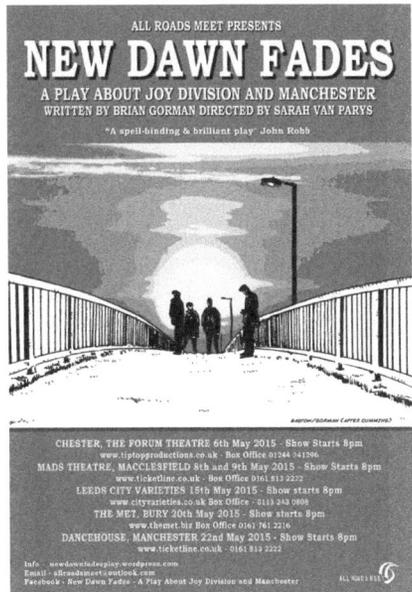

ALL ROADS MEET PRESENTS

## NEW DAWN FADES
### A PLAY ABOUT JOY DIVISION AND MANCHESTER
WRITTEN BY BRIAN GORMAN DIRECTED BY SARAH VAN PARYS
"A spell-binding & brilliant play" John Robb

CHESTER, THE FORUM THEATRE 6th May 2015 - Show Starts 8pm
www.tiptopproductions.co.uk - Box Office 01244 341306.
MADS THEATRE, MACCLESFIELD 8th and 9th May 2015 - Show Starts 8pm
www.ticketline.co.uk - Box Office 0161 813 2222
LEEDS CITY VARIETIES 15th May 2015 - Show starts 8pm
www.cityvarieties.co.uk Box Office - 0113 243 0808
THE MET, BURY 20th May 2015 - Show starts 8pm
www.themet.biz Box Office 0161 761 2216
DANCEHOUSE, MANCHESTER 22nd May 2015 - Show Starts 8pm
www.ticketline.co.uk - 0161 813 2222
Info - newdawnfadesplay.wordpress.com
Email - allroadsmeet@outlook.com
Facebook - New Dawn Fades - A Play About Joy Division and Manchester

Joy Division albums, *Unknown Pleasures* and *Closer*, and they became my favourite band. From that moment, I decided I wanted to tell the story of the band, and interweave it with the history of Salford and Manchester. Curtis' enigmatic lyrics seemed to be about places and times

"I TRAVELLED FAR AND WIDE THROUGH MANY DIFFERENT TIMES".

"TO THE CENTRE OF THE CITY WHERE ALL ROADS MEET..."

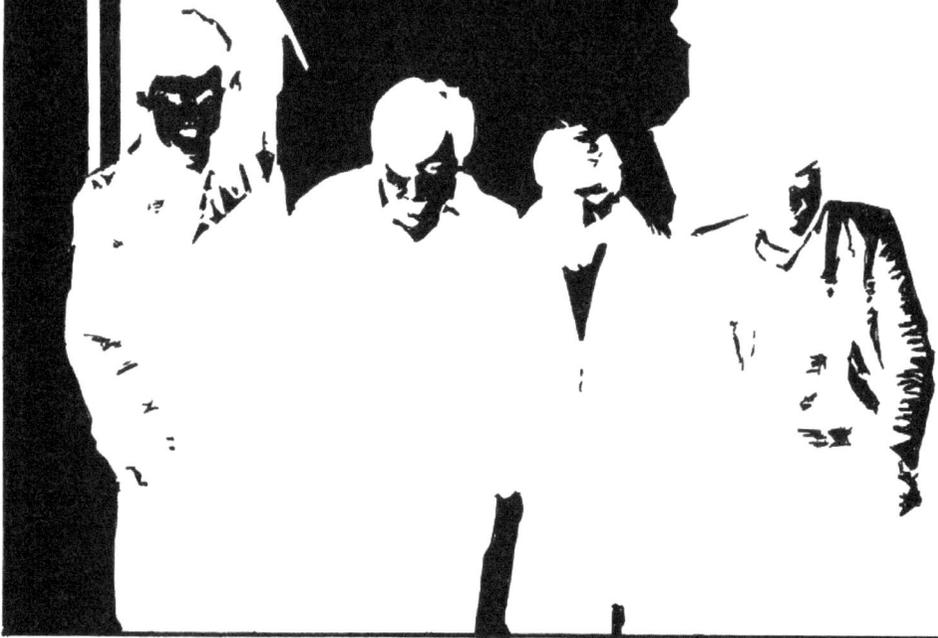

Hanging Bridge

"...WAITING FOR YOU."

overlapping, and the songs were a perfect way to unite all the different elements in the story. As fate would have it, at the same time I met a TV producer from London who was looking to move into publishing, and he offered me the chance to write and draw a series of graphic novels on Manchester bands. For the first one, I suggested Joy Division. Several years later, after I had completed the 140 pages of artwork, and the book was on presale from Simon & Schuster, a few 'technical problems' prevented the book from actually going to print. I then decided to try turning it into a stage-play.

I felt that it was my destiny to write this story. I am a great believer in synchronicity, and when several incredible coincidences happen around the same time, I take that as a sign I am on the right track. My move to Salford (to a house just a couple of streets from where Bernard Sumner and Peter Hook grew up) had coincided with my discovering Joy Division, and feeling a real connection with Ian Curtis. Like him, I had married and had a child in my very early twenties, and quickly discovered I was torn between a normal domestic family life and a career in the arts. My fascination with local history and psychogeography (the effect that certain places have on people) led me to consider a book on my new location, and Ian Curtis' lyrics lent themselves perfectly to this project.

Being quite an introspective person, often feeling alienated from society, and philosophical about life, the universe, and everything, Joy Division's songs felt like a language I truly understood. For those four ordinary young lads to come together at the right time, in the right place, with the right attitude, and create such incredible sounds was a miracle. I am only a few years younger than the band members, and I remember Manchester in the late seventies. I felt they came from the same space (internal and external) that I did. The melancholic and introspective, yet epic and grand sound was a mesmerizing combination. More so than the Sex Pistols (who basically were fuelled by anger), Joy Division really meant what they were saying, and what they were creating. Something special happened when the four elements came together, and the music feels as fresh, honest, and emotionally true now as it did in 1979. Loving the music led directly to writing what is my best stage work, and my most popular. I have a great deal to thank Joy Division for!

I never worked as hard on anything in my life. I was lucky to get the right director and the right cast, and everybody loved it! Starting at the Manchester Fringe Festival in a small room holding thirty-two people, we were subsequently invited to perform in Ian Curtis' hometown of Macclesfield in two sell-out shows with a combined audience of 400. In May 2015, we embarked on a short tour of North West England, where we played the prestigious Leeds City Varieties Music Hall (Charlie Chaplin and Houdini have also performed there), and the Met in Bury (once called the Derby Hall, and the scene of a famous riot during an actual Joy Division gig in 1980). In another twist of fate, Rowetta from the Happy Mondays came to see the show, and was crying at the finale. She said she absolutely loved it. She has sung Joy Division songs on tour with Peter Hook. I hope this is merely the beginning.

# 'THAT IAN CURTIS'

## ROBERT WARHURST

1980. Lennon was still alive. Elvis, Sid, Jim, Marc were all dead and slowly fading from memory. I'm placing the cremated remains of Ian Kevin Curtis into the ground. Just me and him. I sing, *Love Will Tear Us Apart* as I cover the ashes with soil. I walk away.

That was it. Ian Curtis was gone and soon would be forgotten to the world.

It would be about a year or so later, when it first became noticeable that people were starting to visit the crematorium grounds specifically asking for 'the Ian Curtis gravestone'. Only a few initially; yet it was nice to think they, like I, still remembered his music.

But it wouldn't last.

As the 1990s began, they were coming from all parts of the world: Europe, Japan, South America, North America. Often they could speak no English apart from 'Ian Curtis'. I once spent a delightful hour with two Japanese girls; I can't speak Japanese, they only had those two words of English: 'Ian Curtis.' It was more than enough; we were able to communicate, as we shared a passion for the music he'd left behind. And at the end of the day, it is the music that makes these people come and what makes us a community.

Time moved on, the steady trickle of visitors continued, the cemetery and crematorium staff became experts at spotting a 'Curtis'. The office door would open, in they would walk; yet before they could speak, one of us would say, 'Ian Curtis?'

We always got it right!

Over the years, there have been regular visitors; but most are making a one-off pilgrimage. Young, old or somewhere in between. Male, female, on their own, in twos, threes, fours, some eccentric, some that wouldn't have been out of place behind the counter at the dole office where Ian used to work.

They would be given a map, they'd visit the kerb, some leaving a tribute or a personal message; then they'd leave, some to visit Barton Street (to see the house where Curtis once lived), most to head home.

One day ten years or so ago, I'm in the cemetery office, a letter arrives from the

United States. It is passed to me, 'here you go, you can answer this, it's about that Ian Curtis.'

Note the phraseology: 'that Ian Curtis' — despite the cemetery staff being all locally born and bred, or long term residents. They, like ninety-nine per cent of Macclesfield people, don't know the music of Joy Division, or who Ian Curtis was. This is the anomaly: he is the most famous person in the town cemetery, yet the majority of the town do not know who he is.

Back to the letter.

'I'm doing a degree on fandom, can I ask a few questions about Ian Curtis, you may remember me, I came in to the office about eighteen months ago when I visited Ian's kerb.' That American lady is of course Jennifer Otter Bickerdike, who has edited this book. Of course, we remembered her.

If you have been fortunate enough to meet Jen, you'll know what I mean.

I'll belt up now, but before I go, I'll say one more thing. Ian Curtis was a scally from a backwater Northern town, albeit a gifted scally. But he had such short career, a career that apart from a select few, was anonymous to the world at large.

So, if you'd said on that summer day in 1980 by the time of the thirtieth anniversary of his death, that people from the four corners of the globe would come to the kerb, that national newspapers would have articles about him, that there would be two feature films about him, that the theft of his memorial stone would make news across the world… well, I'd have laughed my little cotton socks off.

And you know what? I think Ian would have too.

# JOY DIVISION

## Merchandising the devotion

### LIAM QUINN

I grew up in a dim industrial English town, Burton-on-Trent. There wasn't much to do as a teenager except walking around the shopping centre causing mischief. It was fairly difficult to stand out from the crowd in the mid-2000s without getting the piss taken out of you on every street corner for wearing drainpipes and creepers. Most males my age were wearing grey tracksuits and Carbrini polos. I was lucky to find an escape with music, playing in various punk and ska bands, even if the local scene wasn't great with the closure of the most popular venues.

It wasn't cool to listen to punk rock when I was growing up. No one else listened to it. It was dead. For me it was an escape. I'd sit down every day playing guitar to Green Day and Joy Division, two iconic bands that I found myself locking onto and spending time, effort and money devoting myself to.

I got into Joy Division in my early teens. My parents listened to a variety of music, mainly centred around 1980s alternative — punk, ska and random eighties stuff such as the Clash, Madness, the Specials, Big Country, the Mission, Sisters Of Mercy, Dead Kennedys, the Ramones and New Order — which is how I eventually had these bands and Joy Division sprung upon me. I remember my dad saying to me, 'Listen to this band called Joy Division, you'd love them.' Then I heard about Ian Curtis, a story which didn't really get through to me as a grumpy, pubescent teen, but that has greatly touched me in my late teens and early twenties, especially with the released of books written by Deborah Curtis, Peter Hook and Bernard Sumner, and the 2006 film *Control*.

I was fortunate to have recently completed a case study as part of my university work, which I conducted on the impact on tourism of Joy Division and the death of Ian Curtis on Macclesfield. I learned a lot about Ian and Joy Division in this time. This included current plans in the balance to have an exhibition set up in Macclesfield to commemorate the work of Ian and Joy Division. I personally think this will be great for the town and give it that long-needed boost of tourism and the positive impact that comes from it. It will also give Joy Division fans something to 'have' and to see, that isn't in a cemetery or an old terraced house. As a Joy Division

fan, I want something that is even more greatly commemorated in the town, where not only fans can gather but from which a new wave of creativity in Macclesfield can spring. During my research, I visited Barton Street, the labour exchange and of course, Macclesfield Cemetery. On my first visit, I sat at Ian's grave for two hours, totally alone. I found this somewhat peaceful, yet life-changing and something I will never forget.

For me, vinyl and music collection is a large part of being a Joy Division fan. This is because the band hasn't existed since May 1980. I've always been a collector. For instance, I own everything Green Day has ever released both on CD and vinyl, bar a few singles. I've only had a record player about two years, as I'm more of a portable, on the move CD person. But after buying a USB vinyl player, this changed. It allows vinyl records, obviously never intended for portable purposes, to be imported onto electronic devices. Although I like to have

my music on the go, I also have to own and hold it. I don't download music, I have to have the physical record or CD in front of me and I want to see my collection grow. The first Joy Division record I bought was a 1981 Spanish pressing of *Unknown Pleasures*. I try to avoid reissues as I feel this removes the whole nostalgia and character from not only the quality of the sound but also the look and feel of the record, which, for me, is paramount. I also own early 1980s pressings of *Closer* and *Still*, which I bought from a record fair in Plymouth for fairly decent prices, along with a first week UK pressing of *Substance*. I look on eBay frequently for records in general, and in particular Joy Division, in the hope of a gem. I have come across an original *An Ideal for Living* EP, asking price £1,900, with some collectors valuing the EP even higher. If I had the money I would have snapped it up in an instant. In May 2015, I also came across a copy of *Unknown Pleasures*,

apparently signed by each member of the band at a show in Newcastle in 1979.

There are a lot of bootleg Joy Division items on the internet. These are usually made up of live concert recordings. Among these is the *Warsaw* LP, which was reissued in 2007 on CD and vinyl, and which I own. Bootlegs are great to a record collector such as myself. They help build the record collection. They give me something more to have and hold.

I was talking to someone last week about my case study. She looked slightly confused. 'Why are you doing a case study on a clothing brand?' she asked. That some people evidently think of Joy Division as a clothing brand may be attributed to the proliferation of Joy Division t-shirts, worn by younger people who know little or nothing of what it is they wear. (Much less any deeper significance: for instance, the critique of the band name over the years because of its Nazi connotation.) The Beatles, the Ramones, Rolling Stones and Kiss also fell victim to this rise in cool if 'meaningless' clothing brands. I came across a t-shirt a few weeks ago, which bore the iconic *Unknown Pleasures* artwork and the words 'What is this? I've seen it on Tumblr', in reference to the popular social network on which Joy Division is just one of many other commodities.

This sort of apparel isn't only found in cheap and cheerful high street chains such as Primark and H&M. An official Disney t-shirt models the *Unknown Pleasures* artwork into a Mickey Mouse head. To my knowledge, Disney isn't associated with the band, its music or its members beyond this item of clothing, which specifically acknowledges Joy Division as its inspiration in marketing notes.

Being a young Joy Division fan here and now, is very different from being an 'original' fan. This may be because we haven't had the privilege of being in a world where Joy Division were an active... *thing*. It's also a sad thing, from my point of view, not being able to have been a part of the incredible music scene that was happening in North West England during that time.

Joy Division has become a very materialized brand. You only have to go onto eBay to find thousands of different items ranging from t-shirts and CDs to mugs, stickers and baby grows. During my research, I found the amount of Joy Division and Ian Curtis fan pages and websites astounding, some coming from countries that Joy Division never played in. This has increased the awareness of the band way beyond what was imagined in the late 1970s. Does this really mean that people know what Joy Division was or what it has become?

# UNKNOWN PLEASURES

## and the Revolutions Brewing Company

**MARK SEAMAN**

We are a 'craft' brewery, established in 2010 by two guys with a passion for beer and music. In order to stand out from the many great, good and not so good breweries, we decided to use music as the theme for our brewery and its beers — but not just any music! It would be the music that inspired us and formed the soundtrack to our lives, primarily punk, post-punk and new wave music, referencing singles, albums and artists from the new wave explosion of the late seventies and early eighties.

Early examples of this theme were beers such as Clash London Porter, Kraftwerk Braun Ale and Manifesto Strong Stout. These beers formed the core of our range, with names and beer styles that would hopefully resonate with the beer-buying public and make a name for ourselves in a

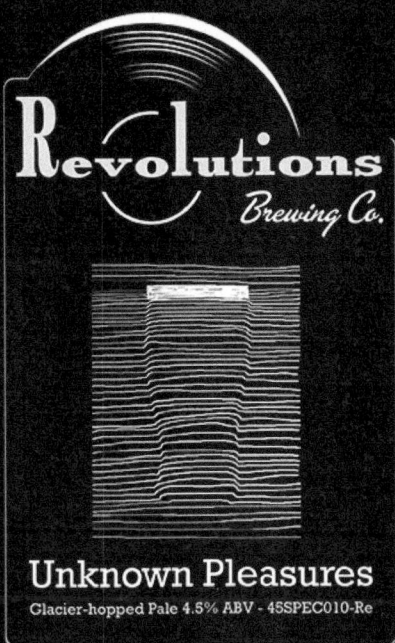

## Unknown Pleasures

Glacier-hopped Pale 4.5% ABV - 45SPEC010-Re

highly competitive industry. To stretch the music analogy yet further, we specialize in beers of 4.5% ABV, chosen to highlight the 45 rpm of vinyl singles.

As recognition grew for the quality of our beers and beer buyers recognized us as the brewery that makes music related beers, we began to produce one-off special beers on a monthly basis. This allowed us to make some interesting, challenging beers that would only be available as limited editions. We decided to call this the 'Rewind 33' series, the title coming from the fact that we would reference music from thirty-three years earlier.

When it came to 2012 and time to reference the music of 1979, we wasted no time in making a beer in homage to one of our favourite bands and favourite albums. The very first special of 2012 was *Unknown Pleasures* — such a great album, but for our purposes, a splendid name for a beer, with all the mysterious connotations that the title conjures up.

We made sure to use a new, unusual

American hop called Glacier to flavour the beer, primarily to offer 'unknown pleasures' to the drinker's palate, but also to reflect the 'glacial' style of Martin Hannett's production referred to by critics at the time of the album's release. The beer was a crisp pale ale — hopefully as refreshing and exciting to the taste buds as the music was to the ears.

We also take great pride in referencing the original album artwork in the beer pumpclip for all our specials, with the graphics for our version of *Unknown Pleasures* drawing on the original iconic imagery. We were so pleased with the results we produced a batch of t-shirts! Something that will at least last longer than the beer did!

In yet another imitation of the music industry, summer 2015 will see our first 'reissue'. Peter Hook and the Light will be headlining Willowman festival, near Thirsk. *Unknown Pleasures* the beer will make an appearance to hopefully accompany some of the songs on stage.

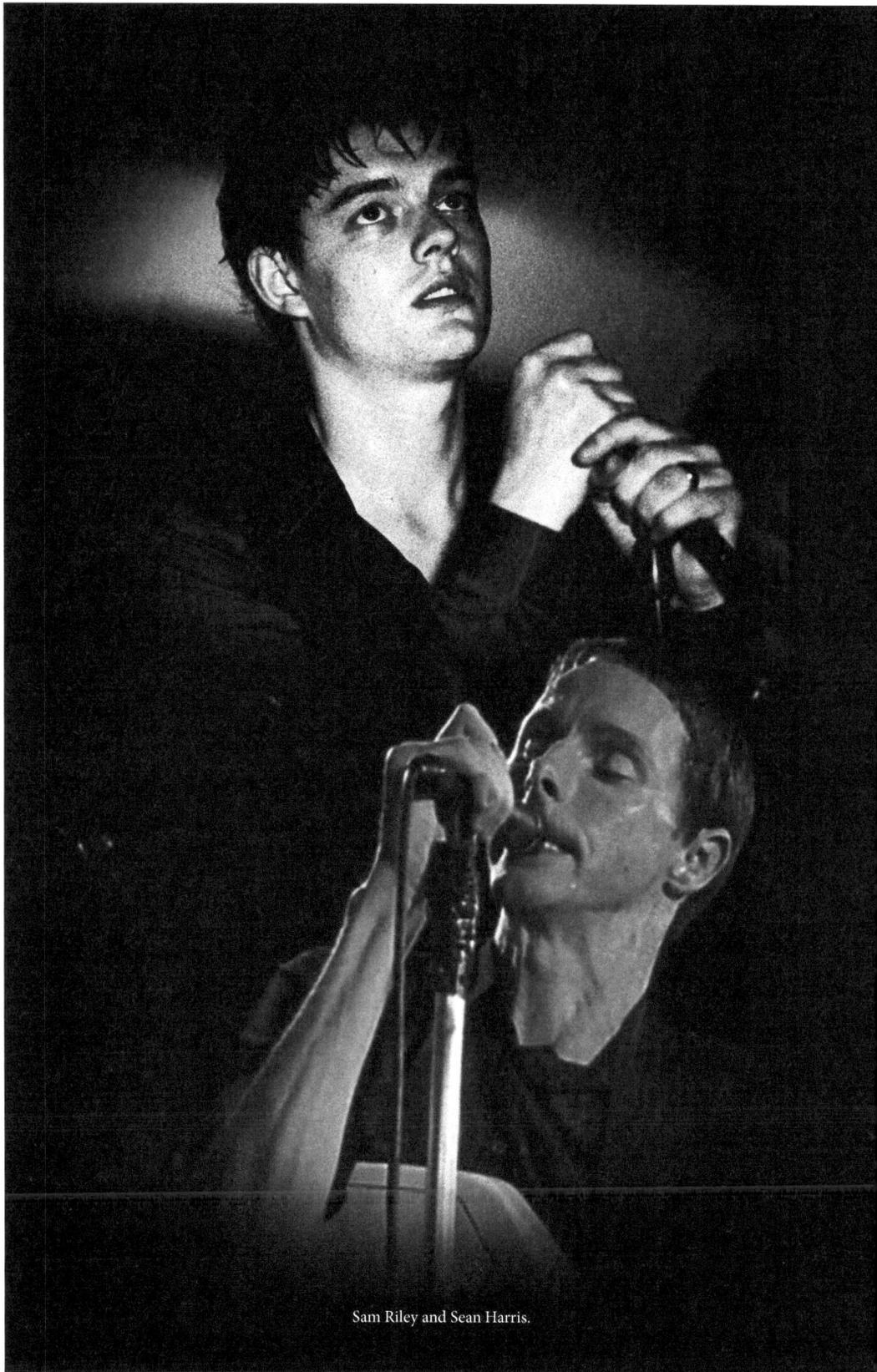

Sam Riley and Sean Harris.

# TWO IAN CURTISES

## DAVID KEREKES

**U**nlike many stars who died tragically young, Ian Curtis left only fragments behind. Beyond the canon of Joy Division music and a smattering of televised performances, there is little, almost nothing, by way of audio-visual documentation.

Instead, our image of Ian Curtis comes through those who knew him and via two dramatizations, music biopics a half decade apart. The first of these biopics is *24 Hour Party People* (d: Michael Winterbottom, 2002), the story of Factory Records, depicted here as a game of two halves with the heavy gravitas of Joy Division lurching suddenly into the pantomime of the Happy Mondays. The second is *Control* (d: Anton Corbijn, 2007), about Joy Division and Ian Curtis specifically.

Sean Harris plays Curtis in *24 Hour Party People*. His manner is a joyless lobster, a pinched threat eager to deflate anyone with expectations equal to or greater than his own. In *Control* it is Sam Riley, a more kindly and sympathetic presence, but ill equipped to cope with domesticity or stardom.

These opposing performances construct two very specific portraits of Curtis. Only those who knew the artist, of course, can say which, if either, is more accurate. Likely the truth is an amalgam. But that's barely the point. An archive interview with BBC radio reveals Curtis to be warm, quietly spoken, evidently intelligent, and with a sense of humour. It is not the Curtis who yells "cunt!" at Tony Wilson from across a bar room in *24 Hour Party People*. Television personality and founder of Factory Records, Wilson recalls that first meeting with Curtis in his book, *24 Hour Party People* (itself based on a screenplay written by Frank Cottrell Boyce). The book is prefaced by a suitably elegiac Wilsonism: that some of what you will read is fact, but much of it is fabricated. He is a 'scrawny young lad,' writes Wilson, 'at the other side of the pool table. Intense. Intense eyes. And a mouth on him.' This is Wilson's introduction to Curtis. It is our introduction to Sean Harris, an actor no stranger to intensity, later finding lead roles as murderer Ian Brady (*See No Evil: The Moors Murderers*, 2006), a homicidal racist (*Outlaw*, 2007) and a megalomaniac

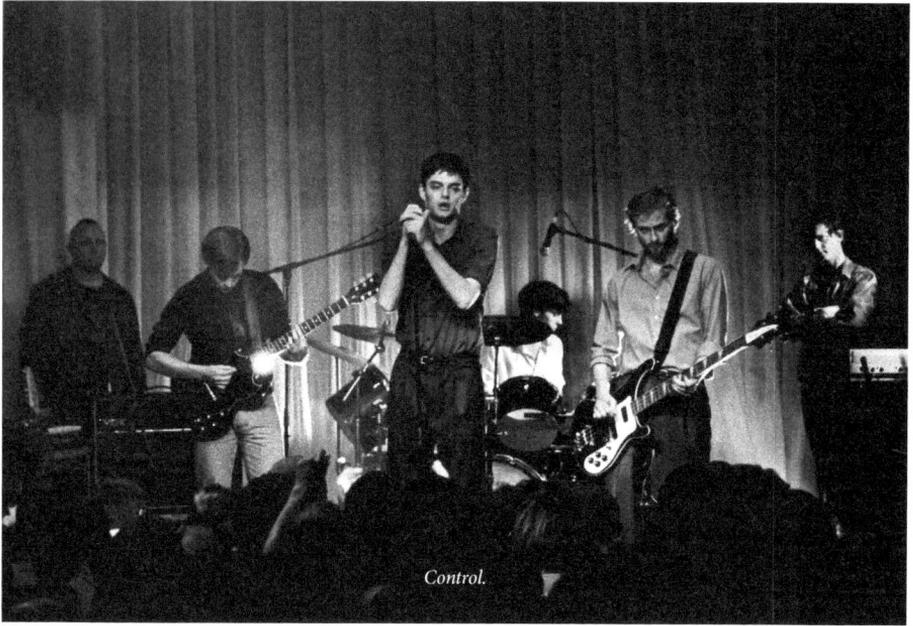
*Control.* ▼

bent on world domination (*Mission: Impossible Rogue Nation*, 2015).

The pool table episode also appears in *Control*. But the outbursts differ. Here it begins with Sam Riley sharing conspiratorial looks with his bandmates, before he marches off to a table where Wilson is sitting and confronts him. A whisper in his ear. He quietly calls Wilson a twat for not yet putting his band on the television show he hosts. He gives Wilson a piece of paper that carries the name of the band — Joy Division — and the words 'you cunt'. Compared with Harris, Riley's remonstration in *Control* appears schooled and wise, befitting an actor who would one day play Jack Kerouac (*On the Road*, 2012).

Both films offer a compelling take on the people and events orbiting Curtis before his death in 1980. Wilson's biography, unhinged as it is, falls somewhere between the two. For instance, in the film *24 Hour Party People*, Curtis has a seizure on stage and is retired to the dressing room, followed by the rest of the band who are pissed off at the abrupt curtailment of an otherwise good gig. In *Control*, the seizure is hardly unexpected and the band continues the song without Curtis. Spirits are high after a 'blinding' gig and the band pays no heed to the collapsed singer in the dressing room. Instead they go off to celebrate. In his book, Wilson recounts how Curtis' epileptic fits were familiar to the band, often taking hold during a live performance. Moreover, the band performed expecting them. 'Towards the end of a set,' says Wilson, 'as *Transmission* would rev up and Ian hit the third verse at top intensity straight out of the second chorus, Bernard [Sumner] and Peter [Hook] would angle in and watch their lead singer carefully.' The intensity of Curtis' spastic dance was an indication of whether he was headed for a fit. They

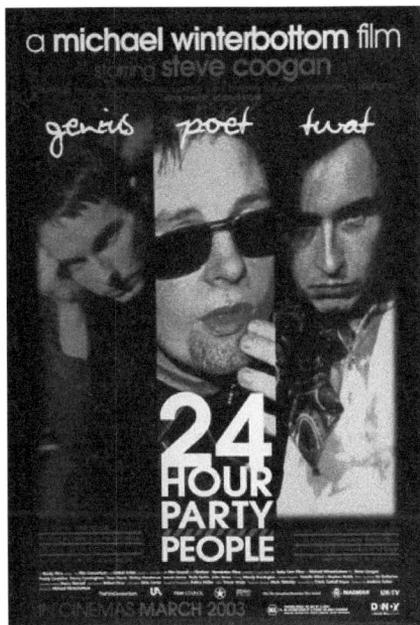

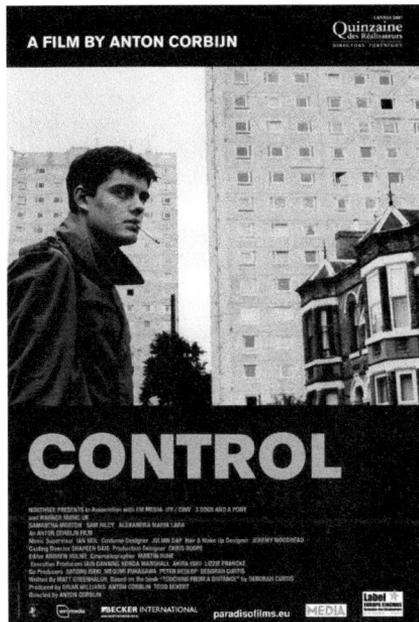

could tell if 'he was meaning it too much'. Some nights Curtis made it through to the end of the gig; other nights he got no further than that particular song.

Riley in *Control* blames himself for everything: his infidelity to Debbie, his wife, through to a riot at a gig and all points in between. He pours his heart and soul into his lyrics, but carries so much weight across the latter half of the picture that breaking point is inevitable. Harris, on the other hand, barely seems to care one way or the other. If he takes a moment to write lyrics we certainly don't see it. His manner is the polar opposite to Riley, far from the sensitive creative type and closer to that of a goon. Ian Curtis #1 probably wouldn't get along with Ian Curtis #2. When Harris snaps it is unforeseen and unexpected: he watches some boring programme on late night television and hangs himself in front of it. He does not watch as much of the boring programme as Riley, who is gripped in front of the box through the night by alcohol, inner demons and then another terrible fit as he comprehends the collapse of his marriage, and — as he sees it — a life in flames.

Wilson considered Curtis' death a 'romantic altruistic suicide'. Not much by way of recorded documents exist of the real Ian Curtis, but his demise — in common with his peers, dead like him at such a young age — is surrounded by speculation and rumour. Before the internet, before the movies cited above, some believed Ian Curtis of Joy Division was discovered hanged not at home but from a lamp post in the street. There was another, stranger rumour that Curtis' suicide was a fiction, that he simply took flight one day, recoiling from the budding pressure of stardom for a whole new life as someone else. Jim Morrison, perhaps? Or Sam Riley? Or Sean Harris?

# DEAD SOULS

## JOY DIVISION

IAN CURTIS
BENEFITING THE

# TRIBUTE

MEMORIAL NIGHT
2014 SF AIDS RIDE

ROADSIDE MEMORIAL
THE INK BATS
DJ SAGE / DEATHGUILD AND DARK SPARKLE

# SATURDAY MAY 24
# THEE PARKSIDE
1600 SEVENTEENTH STREET
SAN FRANCISCO
NINE PM    EIGHT DOLLARS    21UP

# ON TRIBUTE BANDS

## DAVE TIBBS

## PART ONE

On a warm Saturday night in June 2004, I walked into the much-beloved Eagle Tavern in San Francisco's South of Market District. One part gay biker bar, one part live music venue, it is a special place. That evening, members of local rock bands Waycross, the Quails and Dirty Power performed together as an indie rock supergroup, Enorchestra, formed especially to play Brian Eno's second album *Taking Tiger Mountain (by Strategy)* from 1974.

Eno has been a hero of mine for a long time and that album, widely considered his best, has always been my favourite. I couldn't believe that a band existed specifically to perform the entire album. That may have been the first time I had seen a proper tribute band — or at least the first time I had realized what a tribute band was. Until then, I had only seen 'cover' bands. The level of fandom in the air that night impressed me. Both the band and the audience had come together for one purpose: to celebrate Eno's masterpiece.

There is an important distinction between a cover band and a tribute band. A cover band simply covers songs of other artists, often covering several artists in one performance. They also do their own versions of the songs which can be quite creative and entertaining. Dread Zeppelin comes to mind. Performing Led Zeppelin songs in a reggae style, Dread Zeppelin tear it up onstage and put on a really fun show. Cover bands can, obviously, also be disappointing. Led Zeppelin aren't a particularly meaningful band in my life; but if they hold a dear place in your heart, Dread Zeppelin might be seen as downright blasphemous. Either way, it is what it is. A cover band is one that performs other people's music.

A tribute band is a somewhat different animal. Enorchestra is a tribute band and the confident performance and skilful authenticity with which they recreated *Taking Tiger Mountain* was not only a gift to this Eno fan, but an inspiration to form my own tribute to Joy Division.

# PART TWO

Joy Division has meant a lot to me since I was in my late teens. Although I had listened to alternative music before, nothing spoke to me as clearly as Ian Curtis' lyrics. When paired with the soundscape laid down by the other members of Joy Division — Peter Hook, Bernard Sumner and Stephen Morris — the band painted a picture of a mysterious reality. I began to recognize, however, that it was a reality that I inhabited as well. Even though I lived half a world away, and that music had been made a decade prior, I knew that there was something I had in common with these young Mancunians.

I grew up in a conservative town in Northern California and never felt at home. I felt I experienced the world in a different way than most people around me. I didn't feel better than others or privy to some enlightened worldview; I just didn't like what I was seeing around me. There was always the threat of violence toward anyone that was different and that threat occasionally erupted into frightening beatdowns intended to keep the freaks in their place. My opportunities to grow and become the person I wanted to be were limited there. I felt isolated and had to find a way to get out. These themes are at the heart of much of Joy Division's work and many fans are drawn to them because they identify with the feelings of alienation that Ian sang about.

I moved out of my hometown to San Francisco and became involved in a thriving music scene, leftist politics, activism and non-profit work. On the evening I saw Enorchestra, I realized how much Joy Division had meant to me over the years. I thought about how they saw the world as a cold, threatening place, a place they didn't quite understand but were trapped in nonetheless. That was my world, too, for much of my life; Joy Division helped me recognize it and do what I needed to do to build a better life.

After I decided to form the tribute band and did more reading about Ian Curtis, I discovered how much he and I had in common. We both had careers supporting adults with developmental disabilities, we were both Cancers (if you believe in that sort of thing), we were politicized (although at opposite ends of the spectrum), were prone to impulsive behaviour and were passionate about music. Add to those personality traits the fact that I look and sound a bit like him and my mission became clear. I set about finding friends with whom to learn some Joy Division songs.

After several years of lineup and name changes, Dead Souls was formed to pay tribute to Joy Division by performing their songs with as much authenticity as possible. Our love for Joy Division made the regret that we will never get a chance to see them perform in person an almost insatiable feeling. We knew that many others felt the same way and that those people would get satisfaction from seeing a band performing Joy Division's songs almost identically to the originals. We adopted a stage presence reminiscent of the band including dressing like them, Hooky's beard and low-slung bass, Barney's skinny tie, and, yes, Ian's dance. This is, of course, what a tribute band does; but it came naturally to us because of our devotion to Joy Division and our desire to recreate what it would have been like to see the band live.

# PART THREE

An aspect of performing in a tribute band that I've always enjoyed is performing as Joy Division fans for Joy Division fans. In an 'originals' band that writes and performs its own music, there is the band and there are fans of the band. They are separated by the inherent band/fan dynamic much like an invisible wall. A tribute band, however, is made up of fans of the original band just like the people who come to see the tribute band perform. If the tribute band has gained the audience's trust that the performance will be true to the original, that invisible wall can crumble.

A bit of stigma exists about tribute bands, so the task of gaining the audience's confidence is key when trying to break down the band/audience dynamic. A tribute band that puts time and work into presenting the material with care and unapologetic sincerity will have an easier time winning a crowd over than a tribute band that isn't well-rehearsed or lacks focus. This is a job for real fans of the original band and an audience can sense the tribute band's level of devotion.

Is it important for tribute bands to exist? I think in many cases it is and that Enorchestra and Dead Souls can both make good cases for their significance. Brian Eno is still alive but what are the chances that he will perform the music from *Taking Tiger Mountain* again? He probably won't, so the only chance anyone reasonably has of seeing that music performed live is if a tribute band does it. Dead Souls can make an even more solid case for the importance of a Joy Division tribute because the most iconic element of the band, the lead singer, is dead. Ian

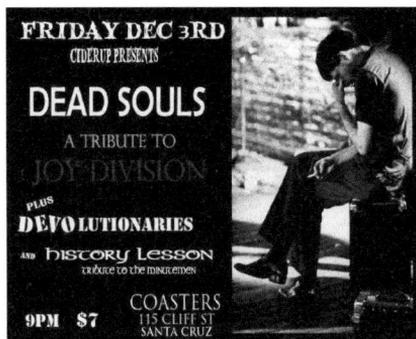

FRIDAY DEC 3RD
CIDERUP PRESENTS
**DEAD SOULS**
A TRIBUTE TO
JOY DIVISION
PLUS
**DEVO**LUTIONARIES
AND hISTORY LESSON
tribute to the minutemen
COASTERS
9PM $7    115 CLIFF ST
SANTA CRUZ

Curtis killed himself in 1980 before hardly anyone in the United States, or elsewhere for that matter, had a chance to see him perform live. The greatest compliments we have received over the years have been from people who regret that they never had a chance to see the original band and that we gave them the closest thing to it they could imagine. In fact, after a Dead Souls show a fellow approached me holding a ticket to the Joy Division show in San Francisco that never happened because Ian committed suicide just before the band was scheduled to fly over from the UK for a US tour. Needless to say, he was very appreciative of what Dead Souls was attempting to accomplish. That moment showed me why being in a tribute band was important.

But, what if a band is paying tribute to an original act that one can still see out on tour? The answer to that question is up to each of us to decide individually, but I personally appreciate a group of fans coming together to commemorate what they love. The biggest lesson I learned from seeing Enorchestra that summer in 2004 may have been to have spirit, celebrate what inspired you to be who you are, and to not apologize for any of it. This is the heart of fandom.

# ACKNOWLEDGEMENTS

I am forever in debt to all of the wonderful, generous fans everywhere who have shared their stories about Joy Division with me. THANK YOU THANK YOU THANK YOU.

I owe my life, my sanity, my marriage, my PhD to Joy Division and the other legendary folks who have been so wonderful to me: Kevin Cummins, Peter Hook, Stephen Morris, Peter Saville, Bernard Sumner. I wish I could have met you, but my endless appreciation to the amazing Rob Gretton, Tony Wilson, and my saviour Ian Curtis.

This would not have happened without my fabulous publisher, David Kerekes, who has been an inspiration and supportive force throughout the whole process.

Thank you to all of the writers who made this possible: Dave Booth, Mark Brodie-Wray, Gail Crowther, Crispin Dale, Brian Gorman, Mike Grimshaw, Philip Kiszely, Neil Robinson, Mark Seaman, Ian Seivwright, Jamie Stewart, Dave Sultan, Robert Warhurst and Jason Whittaker.

Thank you to all of my friends and family around the world, who endlessly believe in me and make me feel like anything is possible. This book and journey would never have occurred without you. Special big hugs and kisses to Chris Baptie, Adrian Bossey, Alix Brodie-Wray, Richard Chamberlain, Gail Crowther, Niamh Downing, Leslie Dotson Van Every, Dan Heichel, Kym Martindale, Chris Rojek, Krista Thorne-Yocam, Tom Ware and to the McPherson family, especially Mary, who have taught me about courage, grace and love — you are a true hero to me.

For my gorgeous, inspiring and insanely patient husband, James. I love you with all my heart.

# DISCOGRAPHY

## DAVID SULTAN

### 1978

**9/6/1978:** ***Short Circuit — Live at the Electric Circus*** **(Virgin Records VCL 5003) 10″ LP:** 5000 blue vinyl (the rest in black), 300 orange vinyl (promo issue only). Produced by Mike Howlett. Design/Artwork & Typography by Russel Mills.

    1. *At a later date*

This is a compilation album of live tracks from the Electric Circus Oct 2, 1977 featuring also The Fall, Steel Pulse, The Drones, John Cooper Clarke, Buzzcocks

**6/1978:** ***An Ideal for Living*** **EP (Enigma PSS 139) 7″ EP: 1000 only.** Recorded at Pennine Sound Studio, Dec 77. Photography Gareth Davy. Cover designed by Bernard Albrecht.

    1. *Warsaw*

    2. *No Love Lost*

    3. *Leaders of Men*

    4. *Failures (of the Modern Man)*

**10/1978:** ***An Ideal for Living*** **EP (Anonymous ANON1) 12″ reissue: 2000 copies only.** Recorded at Pennine Sound Studio, Dec 77. Cover design by Steve McGarry; photography by DB Glen.

    1. *Warsaw*

    2. *No Love Lost*

    3. *Leaders of Men*

    4. *Failures (of the Modern Man)*

Vinyl etching "*Don't ever let it fade away*" (Side A), and "*Feel it closing in*" (Side B), from the lyrics to *Digital*.

### 1979

**1/1979:** ***A Factory Sample*** **(Factory**

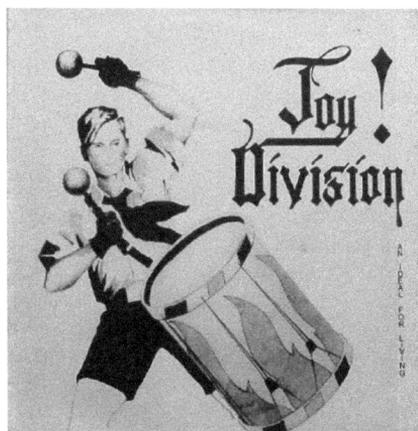

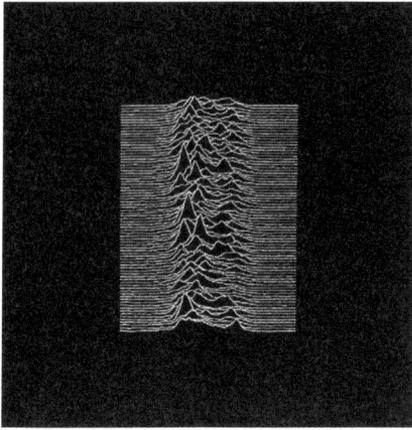

**Records FAC 2) 2 x 7″ singles, 5000 copies only.** Produced by Martin Hannett. Shrink-wrap sleeve with five stickers (Joy Division = a sailor marionette). Design by Peter Saville.

1. *Digital*
2. *Glass*

Compilation featuring also the Durutti Column, John Dowie and Cabaret Voltaire. Vinyl etching Side A (Joy Division): "*Everything*" / Side B (Durutti Column): "*is repairable*" / Side C (John Dowie): "*Everything*" / Side D (Cabaret Voltaire): "*is broken*".

**6/1979: _Unknown Pleasures_ (Factory Records FACT 10) LP.** Produced by Martin Hannett, Engineered by Chris Nagle. Recorded at Strawberry Studios, Stockport. Designed by Joy Division, Peter Saville, Chris Mathan.

1. *Disorder*
2. *Day of the Lords*
3. *Candidate*
4. *Insight*
5. *New Dawn Fades*
6. *She's Lost Control*
7. *Shadowplay*
8. *Wilderness*
9. *Interzone*
10. *I Remember Nothing*

Vinyl etching "*This is the way*" (Side A), and "*Step*" (Side B), from the lyrics to *Atrocity Exhibition*.

**10/1979: _Earcom 2: Contradiction_ (Fast Products FAST 9b) 12″ EP.** Produced by Martin Hannett. Tracks recorded in Apr 79 at Strawberry Studios. Sleeve design Bob Last.

1. *Autosuggestion*
2. *From Safety to Where…?*

Compilation featuring also Thursdays and Basczax.Vinyl etching "*Hey Peel kick out the jams*" (Side B).

**10/1979: _Transmission / Novelty_ (Factory Records FAC 13) 7″ single.** Produced by Martin Hannett. Sleeve design by Peter Saville. Rereleased (12/1980) on 12″ with new cover as FAC 13.12

Vinyl etching 7″ "*And how I'll Never Know*" (Side A), and "*Just Why or Understand*" (Side B), from the lyrics to *She's Lost Control*.

Vinyl etching 12″ "*I've seen the real atrocities*" (Side A), and "*Buried in the sand*" (Side B), from the lyrics to *Ice Age*.

# 1980

**3/1980: _Licht Und Blindheit_ (Sordide Sentimental SS33022) 7″ single**. Produced by Martin Hannett, 1578 numbered copies. Gatefold colour booklet and text by Jean-Pierre Turmel (English translation by Paul Buck) front cover illustration by JF Jamoul and collage by Jean-Pierre Turmel.

1. *Atmosphere*
2. *Dead Souls*

**18/4/1980: _Love Will Tear Us Apart_**

**(Factory Records FAC 23) 7″ single.**
Produced by Martin Hannett. Sleeve design
by Peter Saville. Rereleased (27/6/1980) on
12″ with a new cover FAC 23.12

1. *Love Will Tear Us Apart*
2. *These Days*
3. *Love Will Tear Us Apart*
(Pennine version)

Vinyl etching 7″ "*Don't disillusion me*"
(Side A), and "*I've only got record shops
left*" (Side B)

Vinyl etching 12″ "*Spectacle is a ritual*"
(Side A), and "*Pure Spirit*" (Side B).

**20/6/1980: *Flexidisc* (Factory Records
FAC 28).** Produced by Martin Hannett,

Initial pressing of 25,000 copies — stocks
ran out by the end of July. Free giveaway.

1. *Komakino*
2. *Incubation*
3. *As you said*

Second pressing 25,000 copies November
14, 1980.

**18/7/1980: *Closer* (Factory Records
FACT 25) LP.** Produced by Martin Hannett
at Brittania Row, London. Engineered by
Martin Hannett and John Caffery assisted
by Michael Johnson. Photograph by
Bernard Pierre Wolff. Designed by Peter
Saville, Martyn Atkins, Chris Mathan.

1. *Atrocity exhibition*
2. *Isolation*
3. *Passover*
4. *Colony*
5. *A Means to an End*
6. *Heart & Soul*
7. *Twenty Four Hours*
8. *The Eternal*
9. *Decades*

Vinyl etching "*Old blue?*" (reference to
both a film and to Frank Sinatra)

**2/9/1980: *Atmosphere / She's lost control*
(Factory Records FACUS 2/UK) 12″
Single.** Produced by Martin Hannett.
Sleeve photography by Charles Meecham;
typographics by Peter Saville.

Vinyl etching 12″ "*Here Are The Young
Men*" (Side A), and "*But Where Have They
Been ?*" (Side B), from the lyrics to *Decades*.

# 1981

**8/10/1981: *Still* (Factory Records FACT
40). 2 x 12″ LP.** Sleeve design by Peter
Saville. First 5000 with Hessian cloth cover.
Compilation including many unreleased
tracks produced by Martin Hannett,

Engineered by Chris Nagle.

1. *Exercise one*
(*Unknown Pleasures* session)
2. *Ice Age* (recorded Oct/Nov 79
at Cargo Studios)
3. *The sound of music*
(*Love Will Tear Us Apart* session 1)
4. *Glass* (*Factory Sample* release)
5. *The only mistake*
(*Unknown Pleasures* session)
6. *Walked in line*
(*Unknown Pleasures* session)
7. *The kill* (*Unknown Pleasures* session)
8. *Something must break*
(*Transmission* session)
9. *Dead Souls* (from *Licht und Blinheit*
Sordide Sentimentale release)
10. *Sister ray*
11. *Ceremony*
12. *Shadowplay*
13. *Means to an end*
14. *Passover*
15. *New dawn fades*
16. *Transmission*
17. *Disorder*
18. *Isolation*
19. *Decades*
20. *Digital*

Track 10 recorded live at The Moonlight Club, London, Apr 2, 1980. Tracks 11–20: recorded live at Birmingham University, May 2, 1980.

Vinyl etching "*The chicken won't stop*" (Side A), chicken tracks across the grooves (Sides B & C), "*The chicken stops here*" (side D). "*The chicken won't stop*" is from the Werner Herzog movie, *Stroszek*.

# 1986

**11/1986: *Peel Sessions* (Strange Fruit**

**SFR 13). 12″ EP.** Sleeve designed by Wyke Studios.

1. *Exercise One*
2. *Insight*
3. *She's lost Control*
4. *Transmission*

Recorded Jan 31, 1979. Produced by Bob Sargeant, engineered by Nick Gomm. First broadcast on John Peel radio show Feb 14, 1979.

# 1987

**5/1987: *Peel Sessions* (Strange Fruit SFR 33). 12″ EP.** Sleeve designed by Wyke Studios.

1. *Love Will Tear Us Apart*
2. *Twenty Four Hours*
3. *Colony*
4. *Sound of music*

Recorded Nov 26, 1979. Produced by Tony Wilson, engineered by Dave Dade. First broadcast on John Peel radio show Dec 10, 1979.

# 1988

**6/1988: *Atmosphere* (Factory Records FAC 213).** Sleeve: "*Plus en Min*" (detail) by Jan Van Munster (1986); art direction by Peter Saville; design by Brett Wickens,

JOY DIVISION
1977-1980

Peter Saville Associates; photography by Trevor Key.

**7″ Single**
1. *Atmosphere* 2. *The Only Mistake*
**12″ Single**
1. *Atmosphere* 2. *The Only Mistake*
3. *Sound of music*
**Cassette Single**
1. *Atmosphere* 2. *The Only Mistake*
3. *Sound of music*
**CD Single**
1. *Atmosphere* 2. *Transmission* (live at the Factory, Manchester) 3. *Love Will Tear Us Apart*

7/1988: *Substance: Joy Division 1977–80* **(Factory Records FACT 250).** Sleeve: *Energie-Piek ijs* (detail) by Jan Van Munster (1981); art direction by Peter Saville; design by Brett Wickens; Peter Saville Associates; photography by Trevor Key. Compilation of various releases. Tracks 3–17 produced by Martin Hannett.

**LP** 1. *Warsaw* 12/77 2. *Leaders of men* 12/77 3. *Digital* 12/78 4. *Autosuggestion* 4/79 5. *Transmission* 7/79 6. *She's Lost Control* 7/79 7. *Incubation* 3/80 8. *Dead*

*Souls* 10/79 9. *Atmosphere* 10/79 10. *Love Will Tear Us Apart* 3/80
**CD** Ten tracks of the LP + Appendix: 11) *No Love Lost* 12/77 12. *Failures* 12/77 13. *Glass* 12/78 14. *From Safety to where…?* 4/79 15. *Novelty* 7/79 16. *Komakino* 3/80 17. *These Days* 3/80

# 1990
**1/1990:** *Peel Sessions* **(Strange Fruit SFR 111).** Sleeve design by Peter Saville Associates; photography by Anton Corbijn.
1. *Exercise One*
2. *Insight*
3. *She's lost Control*
4. *Transmission*
5. *Love Will Tear Us Apart*
6. *Twenty Four Hours*
7. *Colony*
8. *Sound of music*
Tracks 1–4: recorded Jan 31, 1979. Produced by Bob Sargeant, engineered by Nick Gomm. First broadcast on John Peel radio show Feb 14, 1979. Tracks 5–8: recorded Nov 26, 1979. Produced by Tony Wilson, engineered by Dave Dade. First broadcast on John Peel radio show Dec 10 1979.

# 1995
**12/6/1995:** *Love Will Tear Us Apart 1995* **(London Records YOJX1).** Art direction Peter Saville. Designed by Howard Wakefield. Photographic images by John Holden.

**12″ Single** 1. *Love Will Tear Us Apart* (original version) 2. *Love Will Tear Us Apart* 1995 (radio version) 3. *Love Will Tear Us Apart* 1995 (Arthur Baker remix) 4. *Atmosphere* (original Hannett 12″)
**Cassette Single** 1. *Love Will Tear Us Apart*

*1995* (radio version) 2. *Love Will Tear Us Apart* (original version)

**CD Single** 1. *Love Will Tear Us Apart 1995* (radio version) 2. *Love Will Tear Us Apart* (original version) 3. *These days* 4. *Transmission* (live)

**26/6/1995: _Permanent_ (London Records 8286242).** Art direction Peter Saville, designed by Howard Wakefield; photography images by John Holden. Compilation of various releases. All tracks produced by Martin Hannett

1. *Love Will Tear Us Apart*
2. *Transmission*
3. *She's lost control*
4. *Shadowplay*
5. *Day of the lords*
6. *Isolation*
7. *Passover*
8. *Heart and soul*
9. *Twenty Four Hours*
10. *These days*
11. *Novelty*
12. *Dead souls*
13. *The only mistake*
14. *Something must break*
15. *Atmosphere*
16. *Love Will Tear Us Apart (Permanent*

*mix)* (Additional production and remix by Don Gehman)

## 1997

**12/1997: _Heart & Soul_ (London Records 8289682) 4CD boxset.** Designed by Peter Saville, Jon Wozencroft and Howard Wakefield. Abstract photography and video stills by Jon Wozencroft. Booklet edited by Jon Savage and Jon Wozencroft.

**Disc one**
1. *Digital*
2. *Glass*
3. *Disorder*
4. *Day of the lords*
5. *Candidate*
6. *Insight*
7. *New Dawn Fades*
8. *She's lost control*
9. *Shadowplay*
10. *Wilderness*
11. *Interzone*
12. *I remember nothing*
13. *Ice age*
14. *Exercise one*
15. *Transmission*
16. *Novelty*
17. *The kill*
18. *The only mistake*
19. *Something must break*
20. *Autosuggestion*
21. *From safety to where...?*

All tracks produced by Martin Hannett, 1 & 2 Recorded at Cargo Studios, Rochdale, 3–18 & 20–21 Strawberry Studios, Stockport. 19 Central Sound, Manchester.

1 & 2 released on *A Factory Sample* (1/79), 3-12 *Unknown Pleasures* (5/79), 13, 14 & 17–19 *Still* (10/81). 15 & 16 7″ Vinyl

(10/79). 20–21 *Earcom 2: Contradiction* (10/79) 1, 2, 15, 16, 20 & 21 *Substance* (7/88). 13, 14, 17, 18 & 19 with added post production.

**Disc Two**

1. *She's lost control 12"*
2. *Sounds and music*
3. *Atmosphere*
4. *Dead souls*
5. *Komakino*
6. *Incubation*
7. *Atrocity exhibition*
8. *Isolation*
9. *Passover*
10. *Colony*
11. *Means to an end*
12. *Heart and soul*
13. *Twenty Four Hours*
14. *The eternal*
15. *Decades*
16. *Love Will Tear Us Apart*
17. *These days*

All tracks produced by Martin Hannett. 1 & 16 Strawberry Studios, Stockport. 2 & 17 Pennine Sound Studios, Oldham. 3 & 4 Recorded at Cargo Studios, Rochdale. 5–15 Britannia Row, London.

1 released on 12" Vinyl (9/80). 2 & 4 *Still* 9 (10–81). 3 & 4 *Licht Und Blindheit* (3/80). 3 12" Vinyl (9/80), 5 & 6 7" Flexi (4/80), 7-15 *Closer* (7/80), 1, 3, 4, 5, 6, 16, 17 *Substance* (7/88).

**Disc Three**

1. *Warsaw*
2. *No love lost*
3. *Leaders of men*
4. *Failures*
5. *The drawback*

JOY DIVISION
Heart & Soul

6. *Interzone*
7. *Shadowplay*
8. *Exercise one*
9. *Insight*
10. *Glass*
11. *Transmission*
12. *Dead souls*
13. *Something must break*
14. *Ice Age*
15. *Walked in line*
16. *These days*
17. *Candidate*
18. *The only mistake*
19. *Chance (Atmosphere)*
20. *Love Will Tear Us Apart*
21. *Colony*
22. *As you said*
23. *Ceremony*
24. *In a lonely place (detail)*

1–4 produced by Warsaw, 5–7 John Anderson, Bob Auger, Richard Searling & Joy Division. 8 Bob Sargeant. 9–11 & 14 Martin Rushent. 12, 13, 15, & 22 Martin Hannett, 16–19 Stuart James, 20 & 21 Tony Wilson. 1–4 & 16–19 recorded at Pennine Sound Studios, Oldham, 5–7 Arrow Studios, Manchester, 6, 8, 20 & 21 BBC Studios, London 9–11 & 14 Eden Studios,

London. 15 Strawberry Studios, Stockport, 12 & 13 Central Sound, Manchester, 22 Britannia Row, London 23 &24 Graveyard Studios, Prestwich.

1–4 released on *An Ideal for Living* 7"Vinyl (6/78). 12″ Vinyl (10/78) & *Substance* (7/88). 5–7, 9–19, 23 & 24 previously unreleased. 8, 20 & 21 broadcast 2/79, 12/79 & *The Peel Sessions* (90). 22 7″ Flexi Disc, uncredited track (4/80) & Video 586 12″ Vinyl (9/97).

5, 6 & 7 RCA demo. 16–19 Piccadilly Radio Session. 9, 10, 11 & 14 Genetic Records Session. 8, 20 & 21 John Peel Session.

**Disc Four**
1. *Dead Souls*
2. *The only mistake*
3. *Insight*
4. *Candidate*
5. *Wilderness*
6. *She's lost control*
7. *Disorder*
8. *Interzone*
9. *Atrocity exhibition*
10. *Novelty*

11. *Autosuggestion*
12. *I remember nothing*
13. *Colony*
14. *These days*
15. *Incubation*
16. *The eternal*
17. *Heart and soul*
18. *Isolation*
19. *She's lost control*

1–10 recorded live at The Factory Hulme 11 Prince of Wales Conference Centre, YMCA, London. 12–14 Winter Gardens, Bournemouth, 15–19 Lyceum Ballroom, London.

# 1999

**6/1999: *Preston, February 28, 1980* (FACD 2.60).** Art direction by Peter Saville, Design by Howard Wakefield and Paul Hetherington at Commercial Art. Photograph by Daniel Meadows.
1. *Incubation*
2. *Wilderness*
3. *Twenty Four Hours*
4. *The eternal*
5. *Heart and soul*
6. *Shadowplay*
7. *Transmission*
8. *Disorder*
9. *Warsaw*
10. *Colony*
11. *Interzone*
12. *She's lost control*

Recorded live at the Warehouse, Preston Feb 28, 1980.

# 2000

**7/2000: *The complete BBC* (Strange Fruit SFR 094).** Designed by The Peter Saville Studio, Photography Jon Wozencroft.
1. *Exercise One*

Joy Division
Les Bains Douches 18 December 1979

2. *Insight*

3. *She's lost Control*

4. *Transmission*

5. *Love Will Tear Us Apart*

6. *Twenty Four Hours*

7. *Colony*

8. *Sound of music*

9. *Transmission*

10. *She's lost control*

11. Interview

Tracks 1–4: recorded Jan 31, 1979. Produced by Bob Sargeant, engineered by Nick Gomm, first broadcast on John Peel radio show Feb 14, 1979. Tracks 5–8: recorded Nov 26, 1979. Produced by Tony Wilson, engineered by Dave Dafe, first broadcast on John Peel radio show Dec 10, 1979. Tracks 9/10: taken from BBCTV Programme *Something Else* recorded Sep 4, 1979. Produced by Mike Bolland. First broadcast on Sep 15, 1979. Track 11: Ian Curtis and Stephen Morris interviewed by Richard Skinner. Produced by Pete Ritzema and Tony Hall. First transmitted in September 1979 on BBC Radio 1.

# 2001

**04/2001: *Les Bains Douches 18 December***

*1979* (**FACD 2.61**). Designed by Howard Wakefield and Paul Hetherington, Art direction by Peter Saville.

1. *Disorder*

2. *Love Will Tear Us Apart*

3. *Insight*

4. *Shadowplay*

5. *Transmission*

6. *Day of the lords*

7. *Twenty Four Hours*

8. *These days*

9. *A means to an end*

10. *Passover*

11. *New dawn fades*

12. *Atrocity exhibition*

13. *Digital*

14. *Dead Souls*

15. *Autosuggestion*

16. *Atmosphere*

1–9 Recorded live at Les Bains Douches, Paris Dec 18, 1979. 10–12 Recorded live Amsterdam Jan 11, 1980. 13–16 Recorded live Eindhoven Jan 18, 1980.

# 2007

**09/2007: *Unknown Pleasures: Remastered and Expanded*** (**London**) **2CD.** Art Direction Peter Saville. Design Saville Parris Wakefield. Digipak in a plastic sleeve + booklet with text by Jon Savage and photographs by Kevin Cummins.

**Disc one**

1. *Disorder*

2. *Day of the lords*

3. *Candidate*

4. *Insight*

5. *New dawn fades*

6. *She's lost control*

7. *Shadowplay*

8. *Wilderness*

9. *Interzone*

10. *I remember nothing*

1–10 Produced by Martin Hannett.

**Disc two**
1. *Dead Souls*
2. *Only Mistake*
3. *Insight*
4. *Candidate*
5. *Wilderness*
6. *She's Lost Control*
7. *Shadowplay*
8. *Disorder*
9. *Interzone*
10. *Atrocity Exhibition*
11. *Novelty*
12. *Transmission*

1–12 Recorded live at Factory Jul 13, 1979.

**09/2007: _Closer: Remastered and Expanded_ (London) 2CD.** Art Direction Peter Saville. Design Saville Parris Wakefield. Digipak in a plastic sleeve + booklet with text by Paul Morley and photographs by Anton Corbijn.

**Disc one**
1. *Atrocity exhibition*

2. *Isolation*
3. *Passover*
4. *Colony*
5. *A means to an end*
6. *Heart and soul*
7. *Twenty Four Hours*
8. *The eternal*
9. *Decades*

1–9 Produced by Martin Hannett.

**Disc two**
1. *Dead Souls*
2. *Glass*
3. *Means to an End*
4. *Twenty Four Hours*
5. *Passover*
6. *Insight*
7. *Colony*
8. *These Days*
9. *Love Will Tear Us Apart*
10. *Isolation*
11. *Eternal*
12. *Digital*

1–12 Recorded live at University of London Union Feb 8, 1980.

**09/2007: _Still: Remastered and Expanded_ (London) 2CD.** Art Direction Peter Saville. Design Saville Parris Wakefield. Digipak in a plastic sleeve + booklet with text by Jon Wozencroft and photographs by Jill Furmanovsky.

**Disc one**
1. *Exercise one*
(*Unknown Pleasures* session)
2. *Ice Age* (recorded Oct/Nov 79 at Cargo Studios)
3. *The sound of music*
(*Love Will Tear Us Apart* session 1)

4. *Glass* (*Factory Sample* release)

5. *The only mistake*
(*Unknown Pleasures* session)

6. *Walked in line*
(*Unknown Pleasures* session)

7. *The kill* (*Unknown Pleasures* session)

8. *Something must break*
(*Transmission* session)

9. *Dead Souls* (from *Licht und
Blinheit* Sordide Sentimentale release)

10. *Sister ray* (live)

11. *Ceremony* (live)

12. *Shadowplay* (live)

13. *Means to an end* (live)

14. *Passover* (live)

15. *New dawn fades* (live)

16. *Transmission* (live)

17. *Disorder* (live)

18. *Isolation* (live)

19. *Decades* (live)

20. *Digital* (live)

1–9 Produced by Martin Hannett. Track 10 recorded live at The Moonlight Club, London, Apr 2, 1980. Tracks 11–20: recorded live at Birmingham University, May 2, 1980. 1–10 Produced by Martin Hannett.

**Disc two**

1. *The Sound Of Music*

2. *Means To An End*

3. *Colony*

4. *Twenty Four Hours*

5. *Isolation*

6. *Love Will Tear Us Apart*

7. *Disorder*

8. *Atrocity Exhibition*

9. *Isolation* (Soundcheck)

10. *Eternal* (Soundcheck)

11. *Ice Age* (Soundcheck)

12. *Disorder* (Soundcheck)

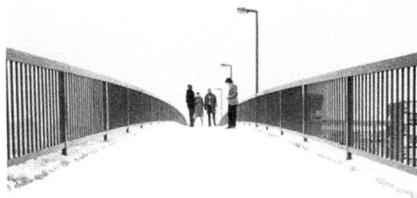

THE BEST OF
JOY DIVISION

13. *Sound Of Music* (Soundcheck)

14. *Eternal* (Soundcheck)

1–14 Recorded live at High Wycombe Feb 20, 1980.

# 2008

**03/2008: *The Best of Joy Division*.** Compilation of various releases. Art Direction Peter Saville, design Saville Parris Wakefield. Photography Kevin Cummins.

**Disc one**

1. *Digital*

2. *Disorder*

3. *Shadowplay*

4. *New Dawn Fades*

5. *Transmission*

6. *Atmosphere*

7. *Dead Souls*

8. *She's Lost Control*

9. *Love Will Tear Us Apart*

10. *These Days*

11. *Twenty Four Hours*

12. *Incubation*

1–12 Studio Tracks All tracks produced by Martin Hannett.

**12/2010: *Joy Division + - (Plus Minus)* 10 x 7″ Box Set individually numbered 1–5000.** Numbers 1–500 available as a super deluxe version and contain a limited edition Peter Saville art piece as well as two exclusive promotional CDs "+" and "-" Retrospective box set consisting of 10 7″ singles on vinyl. All tracks have been newly remastered from original tapes by Stephen Morris and Frank Arkwright (Metropolis Studios). Compiled by journalist and author Jon Savage. Design by Peter Saville.

### Disc two

1. *Exercise one*
2. *Insight*
3. *She's Lost Control*
4. *Transmission*
5. *Love Will Tear Us Apart*
6. *Twenty Four Hours*
7. *Colony*
8. *Sound of Music*
9. *Transmission*
10. *She's Lost Control*
11. Interview

### Vinyl 7″

1. *Warsaw / Leaders of Men*
2. *No Love Lost / Failures*
3. *Digital / Glass*
4. *Autosuggestion / From Safety to Where*
5. *Transmission / Novelty*
6. *Atmosphere / Dead Souls*
7. *Komakino / Incubation & As You Said*
8. *Love Will Tear Us Apart / These Days*
9. *She's Lost Control* (12″ Version) / *Love Will Tear Us Apart 2* (Pennine Version)
10. *Isolation / Heart and Soul*

Tracks 1–4: recorded Jan 31, 1979. Produced by Bob Sargeant, engineered by Nick Gomm, first broadcast on John Peel radio show Feb 14, 1979. Tracks 5–8: recorded Nov 26, 1979. Produced by Tony Wilson, engineered by Dave Dafe, first broadcast on John Peel radio show Dec 10, 1979. Tracks 9/10: taken from BBCTV Programme *Something Else* recorded Sep 4, 1979. Produced by Mike Bolland. First broadcast on Sep 15, 1979. Track 11: Ian Curtis and Stephen Morris interviewed by Richard Skinner. Produced by Pete Ritzema and Tony Hall. First transmitted in September 1979 on BBC Radio 1.

All tracks produced by Martin Hannett.

Rereleased (12/2011) on CD replicas of ten singles presented in clamshell box.

**04/2011: Joy Division / New Order "*Ceremony*" (Rhino CAT: FAC33) 12″ single.** Sleeve design by Studio Parris Wakefield after the original design by Peter Saville. Limited edition (1000 copies) only available at Record Store day Apr 16, 2011 in UK.

**Joy Division** a: *Ceremony* (Previously released *Heart & Soul* rehearsal version) b: *In A Lonely Place* (Unreleased take from a recording of a Joy Division rehearsal session)

**New Order** a: *Ceremony* (Original Version) b: *In A Lonely Place* (12″ Version)

All tracks remastered by Stephen Morris and Frank Arkwright 2011.

**06/2011:** *Total* **(Rhino 5052498647958).**
Art direction Peter Saville, designed by Studio Parris Wakefield. Compilation of various releases from Joy Division to New Order.

1. Joy Division  *Transmission*
2. Joy Division  *Love Will Tear Us Apart*
3. Joy Division  *Isolation*
4. Joy Division  *She's Lost Control*
5. Joy Division  *Atmosphere*
6. New Order  *Ceremony*
7. New Order  *Temptation*
8. New Order  *Blue Monday*
9. New Order  *Thieves Like Us*
10. New Order  *The Perfect Kiss*
11. New Order  *Bizarre Love Triangle*
12. New Order  *True Faith*
13. New Order  *World In Motion*
14. New Order  *Fine Time*
15. New Order  *Regret*
16. New Order  *Crystal*
17. New Order  *Krafty*
18. New Order  *Hellbent*

All tracks remastered by Frank Arkwright at Fluid Mastering 2011.

# 2014

**04/2014: Joy Division** ***An Ideal For Living***
**(Warner Music) 12″ single.** Reissue from a newly cut master for the first ever Joy Division release. New Cover inspired by

TOTAL from Joy Division to New Order

the original 12″ scaffold sleeve (released in 1978). Limited edition (6000 copies in Europe of which 1500 sold in the UK) only available at Record Store day Apr 19, 2014 in UK. Another 7500 were pressed for US market.

1. *Warsaw*
2. *No Love Lost*
3. *Leaders of Men*
4. *Failures (of the Modern Man)*

All tracks remastered in 2010. Vinyl etching "*Don't ever ket it fade away*" (Side A), "*I feel it closing in*" (side B).

117

# CONTRIBUTOR NOTES

### DAVE BOOTH...

was the original Stone Roses DJ. He worked with the band at the seminal Blackpool Winter Gardens, Alexander Palace and Spike Island gigs. He started his career at Pips Disco, where previously he began his clubbing days as an avid Bowie fan. He has since worked all the great Manchester clubs and nights, with particular highlights including Cloud 9, Berlin, the Hangout at Isadora's, the Haçienda, and the Playpen. For the last twenty years he has been resident DJ at Garlands in Liverpool.

### MARK BRODIE-WRAY...

is a music writer, Joy Division fan and resident of Manchester from 1998 to 2010. He has written fanzines and music blogs too numerous to mention over the last fifteen years. His current blog, on fatherhood and music, is called *On a Good Day*, and can be found at www.onagooddayblog.com.

### DR GAIL CROWTHER...

has lectured in Sociology at Lancaster University as well as Religion, Culture and Society at the University of Central Lancashire, and in Social Science for the Open University. She is currently a freelance writer, researcher, and academic. She is co-author of *Sylvia Plath in Devon: A Year's Turning* (2015), author of *The Haunted Reader and Sylvia Plath* (2016), and has written several chapters and papers about Plath. Her research interests aside from Plath, are archival studies, feminist life writing, and sociological hauntings.

### DR CRISPIN DALE...

is a Principal Lecturer in the Faculty of Arts at the University of Wolverhampton. Crispin lectures in the field of cultural heritage and has published widely in books and peer-reviewed journals. His research interests focus on the development of event venues and cultural heritage facilities.

### BRIAN GORMAN ..

was born in Wigan in 1964, and is a Manchester-based writer, artist, actor, and theatre producer. Recent work as a writer includes *New Dawn Fades: A Play About Joy Division*; *Everyman: The Story of Patrick McGoohan — The Prisoner*; *Blade Runner* (adapted from the 1982 screenplay) and *Tuxedo Warrior*.

## DR MIKE GRIMSHAW...

first heard Joy Division in 1981, on the radio, in New Zealand. He still lives there and is Associate Professor in Sociology at the University of Canterbury. He works at the intersections of cultural and social theory, religion and continental thought. It was a conversation about Joy Division in a bar at a conference in Atlanta in 2010 that resulted in the creation of his co-edited series *Radical Theologies* (Palgrave Macmillan) and in particular his editing of *The Counter-Narratives of Radical Theology and Popular Music: Songs of Fear and Trembling* (Palgrave Macmillan: 2014).

## DAVID KEREKES...

was born a short, uneventful bus ride away from Graveyard Studios in Prestwich, where the formative Joy Division recorded a handful of tracks.

## DR PHILIP KISZELEY...

is Director of Student Education in the School of Performance and Cultural Industries at the University of Leeds. He is co-editor of the *Punk & Post-Punk* international peer-reviewed journal and author of the award-nominated *Hollywood Through Private Eyes: The screen adaptation of the 'hard-boiled' private detective novel in the studio era* (2006). A tireless 'Madchester' reveller during the late eighties and early nineties, he is currently writing a book about that scene.

## DR JENNIFER OTTER BICKERDIKE...

is a Senior Lecturer in Music and Brand Management at Falmouth University. She has over twenty years' experience working with tastemakers and cultural provocateurs such as Facebook, Interscope Geffen A&M, Sony Music, Universal Music and Video Distribution and L.A.M.B. She has helped create and implement marketing and promotion plans for some of the world's most iconic artists, including Sting, U2, Eminem, Dr. Dre, Gwen Stefani, Pearl Jam, Rage Against the Machine and a little band called Nirvana. Jennifer's first book *Fandom, Image and Authenticity: Joy Devotion and the Second Lives of Kurt Cobain and Ian Curtis* was published in October 2014 (Palgrave Macmillan), with her second release, *The Secular Religion of Fandom* out in 2015 (Sage). Her next project will be writing a book and producing a documentary movie on famous groupies from the late 1960s.

## LIAM QUINN...

is a twenty-two-year-old, punk/skin, who grew up in Staffordshire, England, before moving to Cornwall to pursue studies in Creative Events Management. He's usually the come-to-guy for Green Day and punk rock.

## NEIL ROBINSON...

lectures at Salford University Business School, teaching at both undergraduate and postgraduate levels. He has research interests in dark tourism and heritage, heritage site

management, stand-up comedy in the dissemination of academia, and musical legacy associated with place.

## MARK SEAMAN...

at fifty-two, is old enough to remember the effect the explosion of punk, post-punk and new wave music had on young impressionable minds, his own included. From black and coloured vinyl to MP3s and streaming, from Siouxsie & the Banshees and Joy Division to Queens of the Stone Age and Wild Beasts, he espouses the ethos of Love Music: Love Beer as co-founder and Director of the Revolutions Brewing Company in Yorkshire.

## IAN SEIVWRIGHT...

saw Joy Division in 1979. It changed his life. He has been going to pay homage to Ian Curtis every May 18th since 1982.

## JAMIE STEWART...

was born in Los Angeles in 1978. He holds a PhD in ornithology from Cornell. In 2002 during a failing field study in Suriname, Stewart, along with former partner Cory McCulloch, formed the band Xiu Xiu. Xiu Xiu have released many albums, collaborative projects and books, and tour the world extensively.

## DAVID SULTAN...

is an intrepid international explorer, author of *True Faith: An Armchair Guide to New Order: Joy Division, Electronic, Monaco and The Other Two* and the founder of worldinmotion.net.

## DAVE TIBBS...

Dave Tibbs (aka Davey Bones) is the lead singer of Dead Souls — A Tribute To Joy Division, the bassist of The Ink Bats, promoter and resident DJ at The Hanging Garden and the author of several other similarly dorky articles.

## ROBERT WARHURST...

is still a young man but his body is getting old. Born and bred in the environs of Manchester. It was once said to him 'you're a musical snob'.
It's true. And he's very happy about it.

## DR JASON WHITTAKER...

is Head of the School of English and Journalism at the University of Lincoln. He writes widely on William Blake and popular culture, as well as digital media and online journalism, and is co-editor of the series *Pop Music, Culture and Identity* with Steve Clark and Tristanne Connolly.

**A HEADPRESS BOOK**
First published by Headpress in 2016

[email]  headoffice@headpress.com
[web]  www.worldheadpress.com

**JOY DEVOTION**
**The Importance of Ian Curtis and Fan Culture**

978-1-909394-28-5    ISBN PAPERBACK
978-1-909394-29-2    ISBN EBOOK
HARDBACK    NO-ISBN

**WWW.WORLDHEADPRESS.COM**
the gospel according to unpopular culture
Special editions of this and other books are available exclusively from Headpress

\* *Ian Curtis*, Thursday

BV - #0109 - 101122 - C14 - 229/152/9 - PB - 9781909394285 - Matt Lamination